BOB ELLIS
STAFF PHOTOGRAPHER

25 YEARS OF PHOTOGRAPHY FOR THE CORTLAND STANDARD

CONTENTS

FORWARD

Twenty-five years ago Bob Ellis decided to make his hobby a money-making proposition and left a large manufacturing plant that time was leaving in the dust — although hundreds of Smith Corona employees didn't know it at the time. He took a job as a staff photographer with the *Cortland Standard*, a small, family-owned daily newspaper in upstate New York.

It was a perfect match. Bob's prizewinning photos of Cortland-area men, women, and children at work and at play quickly became one of the paper's features and his friendly, curious personality made him the newspaper's unofficial goodwill ambassador throughout its circulation area covering several counties.

Bob has seen it all, from darkroom and film to digital cameras and computers: celebration and despair, budding cattle breeders winning their first county fair blue ribbons, flood and fire victims looking with despair at the ruins of their homes, a volunteer firefighter answering his last call, a young mother looking with love and wonder at the first baby of the new year, a high school football player catching the winning pass, a field hockey goal keeper preserving a victory.

For the past 25 years Bob has worked closely with the *Cortland Standard* reporters and editors in deciding which story assignments to photograph and how to photograph them. He has been generous with his own ideas and accepting of suggestions from fellow news staff members.

Bob's special gift is not his artistic and technical expertise, although he has that in abundance, it's his sincere interest in his subjects – an interest that is appreciated and returned by the children, women, and men in his photos and elevates his photos above the rest.

Skip Chapman
Executive Editor
The Cortland Standard

BIOGRAPHY

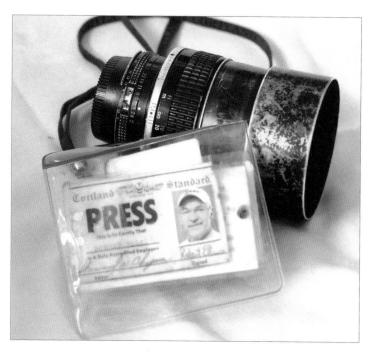

For 25 years, Bob Ellis has been the staff photographer at the *Cortland Standard*, one of the last family-owned daily newspapers in New York State. Completely self-taught, he began his career as a freelance photographer while working for the Smith-Corona typewriter factory in Cortland.

Bob's appreciation for our area's rural beauty is the result of the many miles he and his childhood friends put on their bikes as they rode through the small hamlet of Etna, New York, and surrounding communities. He attributes his eye for sports to years of participation through local softball leagues, love of the New York Yankees, and time spent in the bleachers watching his two daughters play team sports. His eye for the humor and antics of children is well known and much appreciated as he documents his own six grandchildren. His love of local news will often find him glued to a scanner so that he can be the first to arrive at a fire, or if lucky, robbery in progress.

Several of his photographs have also appeared in publications such as *The Washington Post, Houston Chronicle, New York Post, New York Daily News,* and have been transmitted all over the world via Associated Press. He has won multiple awards with the National Press Photographers Association, including the Bernard Kolenberg Memorial Award and Best of Show award in the 1988 New York State Associated Press photo contest.

FEATURES

Feature photographs are the staple of small-town newspapers. They are also my favorite type of photographs to shoot. Attending an event, scouring the crowd, constantly looking for that one photograph that can be humorous, beautiful, or simply something that I've never seen before.

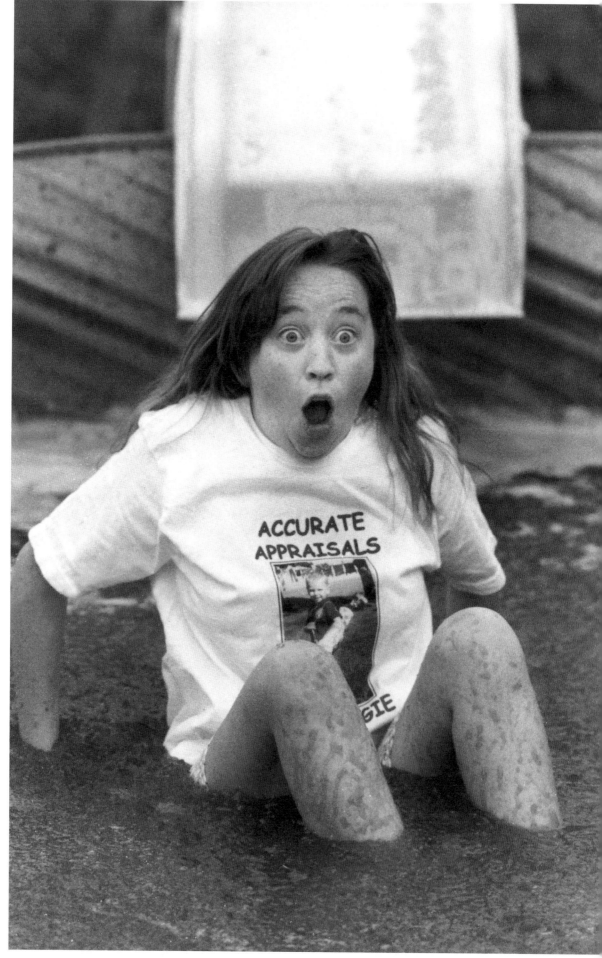

Cold Jello
September 16, 1999

Lisa Morley finds 500 gallons of gelatin a bit cold after sliding into it. The slide was to benefit the Central New York Chapter of the Leukemia Society of America. Forty-eight volunters made the chilly slide, raising over five thousand dollars.

Photo won 1st place in features category in NPPA's monthly clip contest.

ACCURATE APPRAISALS

GIE

6 BOB ELLIS, Staff Photographer

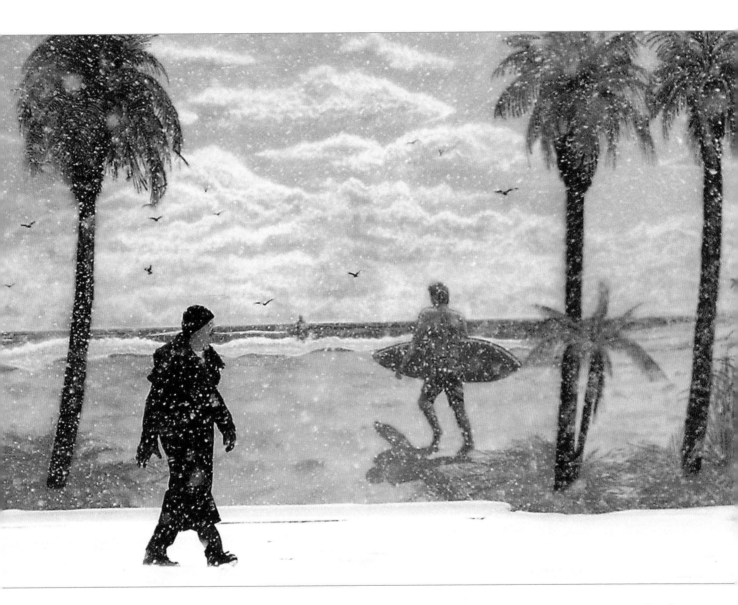

Beach of a Day
January 19, 2005

The closest Mark Peek could get to
thebeach was to walk by this mural
on the side of Tropical Sun tanning
salon.Peek was walking to Tops
Market during aheavy snowfall.

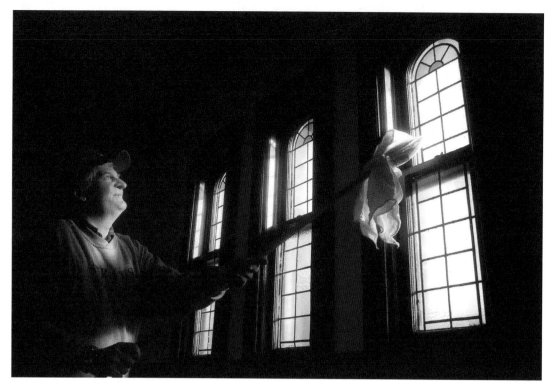

Center for the Arts Duster
October 20, 2007

Morning light shines on Mike Mcgee, maintenence worker at The Center
for the Arts in Homer, as he dusts the stained glass windows in the balcony.

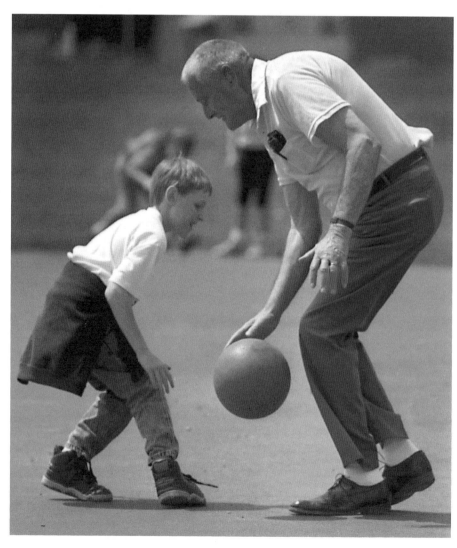

All in the Family
May 20, 1992

Bob Reynolds of Groton,
challenges his grandson
Jason Kaminski to a one-on-
one basketball game during
Grandparents Day at Virgil
Elementary School.

BOB ELLIS, Staff Photographer

Chain Sawing Nudist
July 7, 1988

"Jay" wears shoes and socks and nothing else as he trims a thorn apple tree with a chainsaw at Empire Haven Nudist Park in Summerhill.

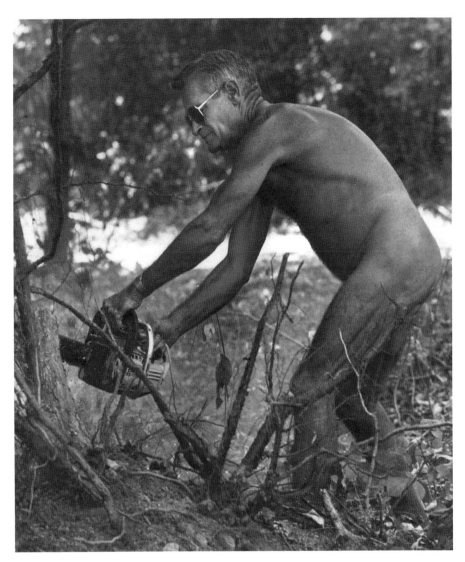

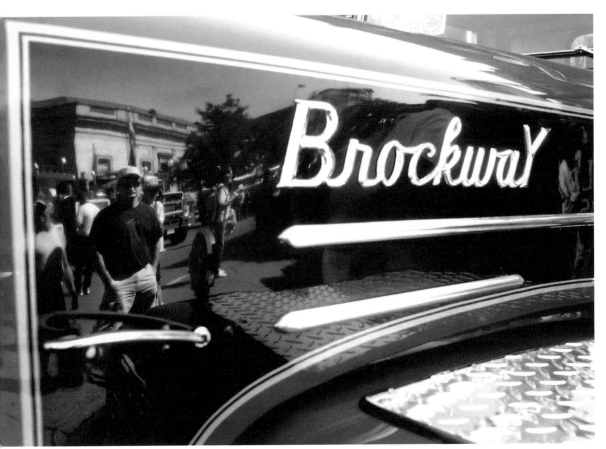

Brockway Show Reflection
August 11, 2007

Jim VanCise, Jr., of Homer, is reflected in the hood of a recently refurbished 1964 Brockway owned by Tom Kile, also of Homer. Main Street in Cortland was hosting the annual Brockway truck show.

Bagel Eating Squirrel
1987

A squirrel munches on a bagel high atop a utility pole in the alley behind the Cortland Standard. The bagel apparently came from a nearby bagel shop.

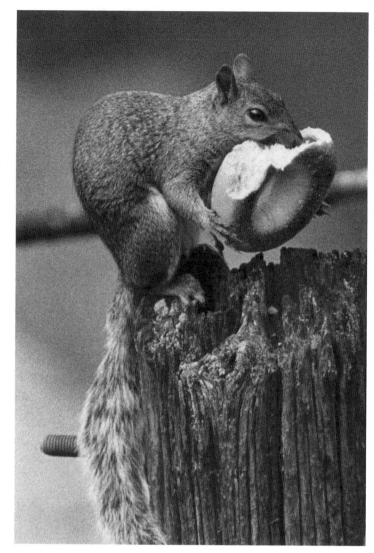

Cortland Fire Department Rapellers
July 29, 2008

Cortland firefighter Nate Crouse, right, rescues his "victim", fellow firefighter Chris Buttino, from the 9th floor window of 42 Church Street. The Cortland Fire Department was conducting a rapelling drill from the roof of the eleven story building.

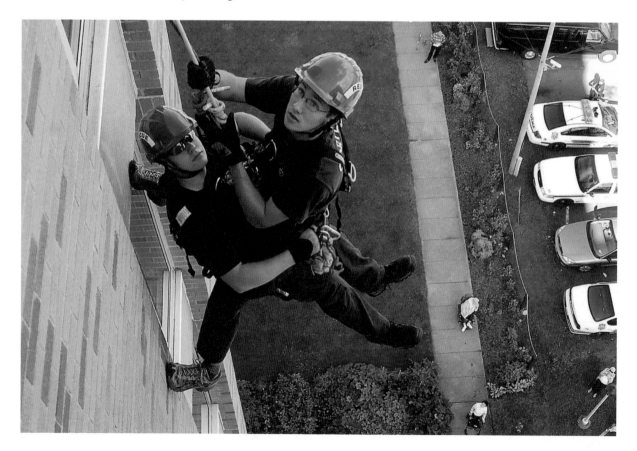

BOB ELLIS, Staff Photographer

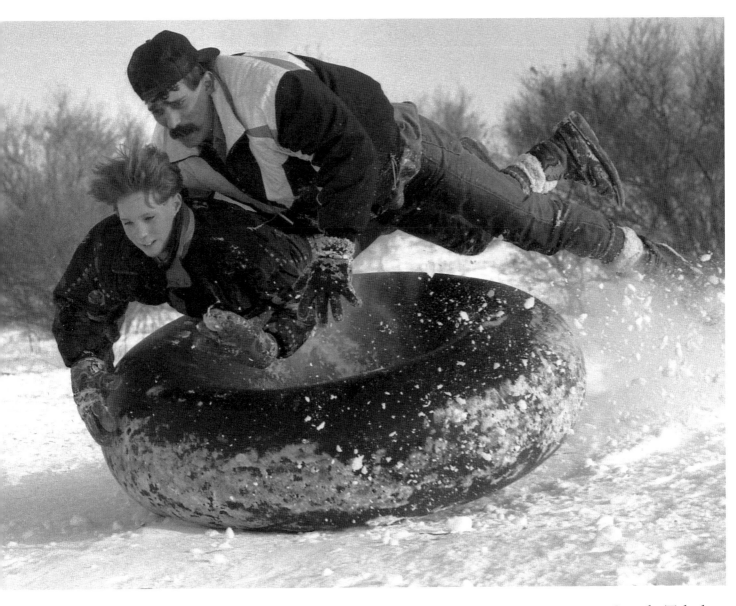

Simply Tubular
February 7, 1992

Ron Miller, top, and Noah Pierson,
are launched into the air as they leap
over a jump aboard their inner tube
at Beaudry Park.

Cortland Rural Chapel
January 16, 2007

Kenneth Nichols, of Summerhill, replaces panes of broken glass in the chapel at Cortland Rural Cemetery on Tompkins Street. Stained glass artist Nichols measures and carefully cuts new glass to replace the broken pieces in the chapel which was built in 1922.

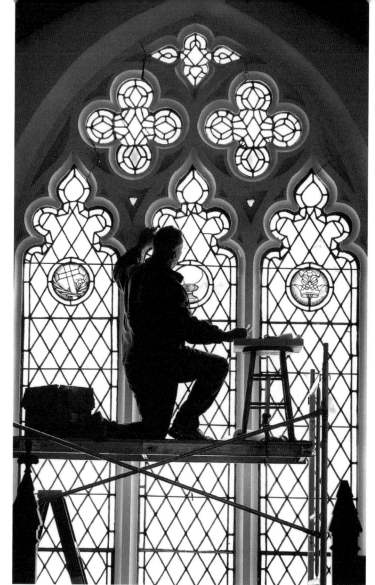

September 11th Vigil
September 10, 2003

About two dozen area residents gathered in Courthouse Park for the Circle Of Hope candlelight vigil in remembrance of those who lost their lives in the 9-11-01 terrorist attacks. The event, sponsored by the Cortland Community for Peace, is part of a worldwide effort initiated by Families for a Peaceful Tomorrow.

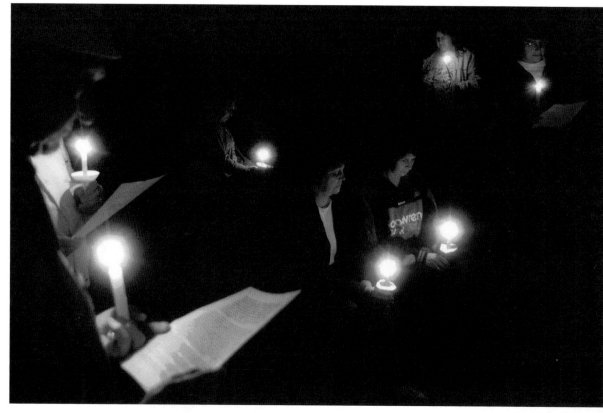

BOB ELLIS, Staff Photographer

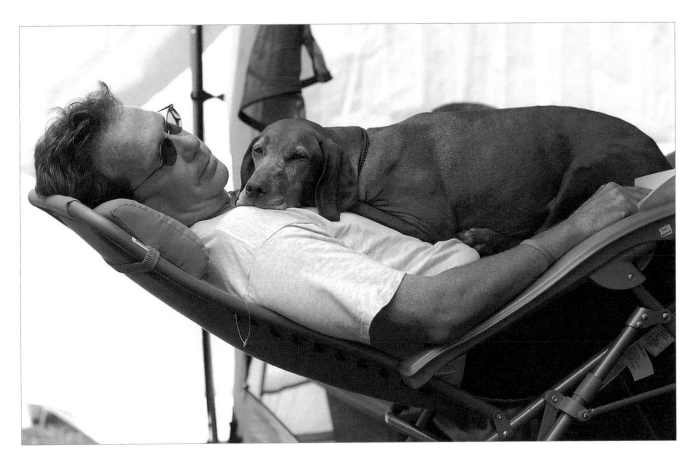

Snoozers
August 5, 2006

Bob Klinetop, of Phoenix, catches a few winks with his dog Nia, a Vizsly, at the Central New York Shetland Sheepdog Trials at Dwyer Memorial Park in Little York.

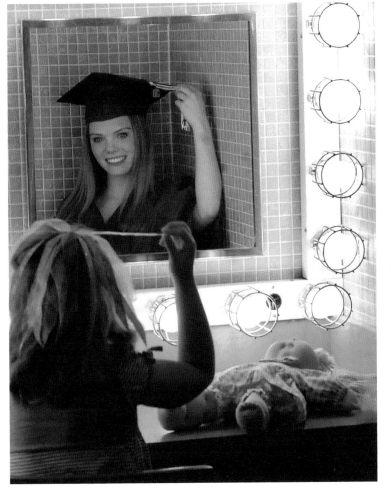

Dreaming of Graduation
May 29, 2008

Photo illustration showing a little girl dreaming of high school graduation. Cortland High graduate Aisling Halpin poses.

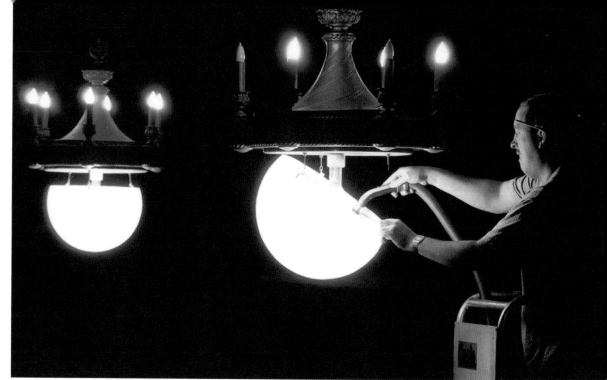

Chandelier Cleaner
May 13, 2002

Douglas Adsit, a cleaner at SUNY Cortland, vacuums dust from a chandelier in Brown Auditorium. Adsit was also replacing bulbs in preparation of the graduation ceremony for the graduate degree program.

Silouette
October 31, 2001

A roofer walks along the roofline of the United Presbyterian Church on Church Street in Cortland. The church was in the process on getting new shingles.

BOB ELLIS, Staff Photographer

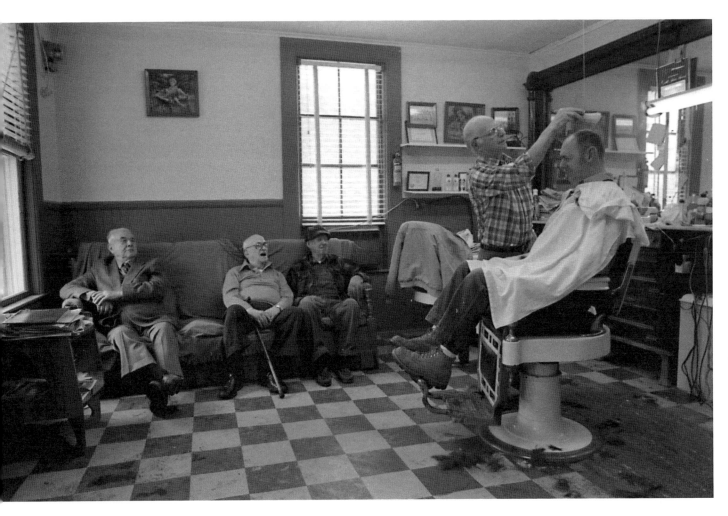

Ferris Barber Shop
March 9, 1988

Seventy-three year old barber Aden Ferris brushes off Bud Alberts, of McGraw, as longtime customers, left to right, George Gilbert, Ed Berean, and Merton Bean wait their turn. Alberts has been coming to the McGraw barber shop for the entire 32 years it has been at 11 Main Street. Ferris has been in the barbering business for over 50 years, learning the trade from his brother in the 1930s.

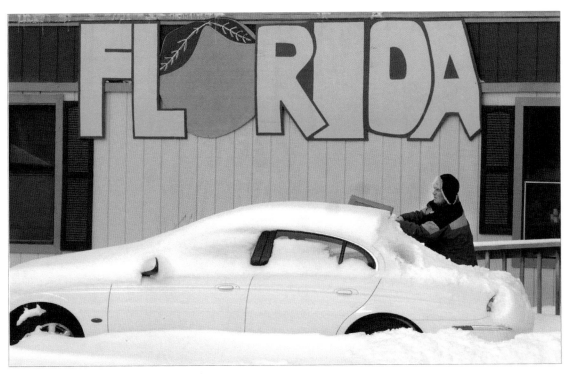

Florida Cars
December 17, 2007

It was anything but Florida weather as Steve Timmons brushes snow from a 2003 Jaguar he has for sale at his business, Tropical Wheels on Route 281 in Cortlandville. Timmons typically buys his pre-owned cars from Florida.

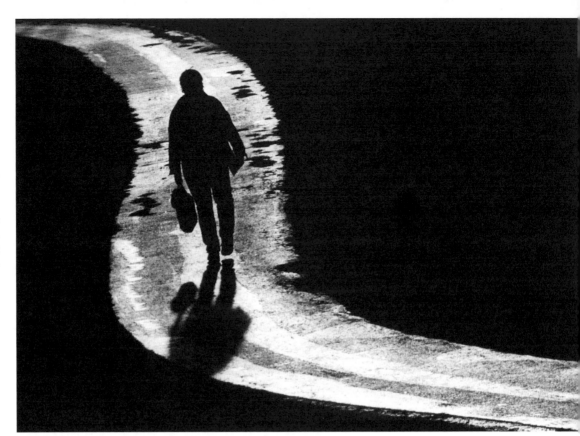

Long Walk Home
1990s

A Cortland High School student is silhoutted against a wet sidewalk as he walks home after school.

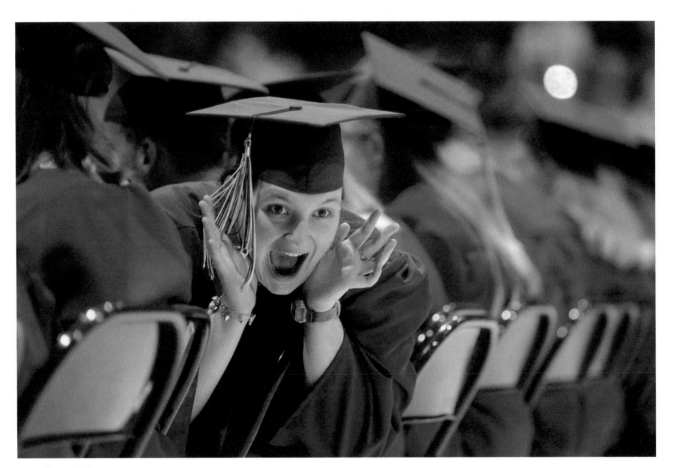

Student Mom
June 22, 2002

Cortland High School graduate Kelly Welch makes faces at her daughter during ceremonies at Alumni Arena in the Park Center. Welch, 20, went back to school to earn her diploma after giving birth eleven months prior.

BOB ELLIS, Staff Photographer

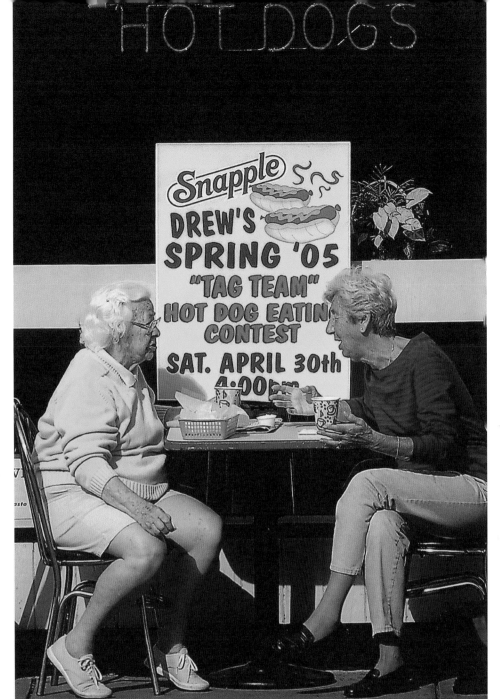

Hot Dogs
March 20, 2005

Henny Brown, left, and Mary Stevens take advantage of 70 degree temperatures as they share conversation and a morning snack outside Drew's Dogs on Main Street in Cortland. The women met every morning at Drew's.

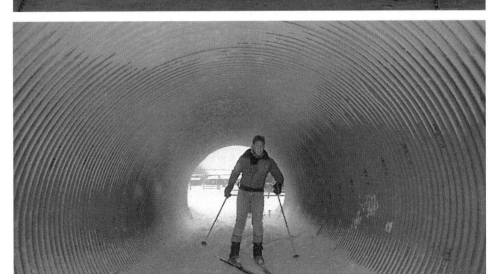

Greek Peak Tunnel
January 9, 1988

Pete Rumsey, of Dryden, skis through a tunnel to another slope while skiing at Greek Peak in Virgil.

Only the Lonely
December 30, 2003

A pedestrian makes his way across Port Watson Street in Cortland.

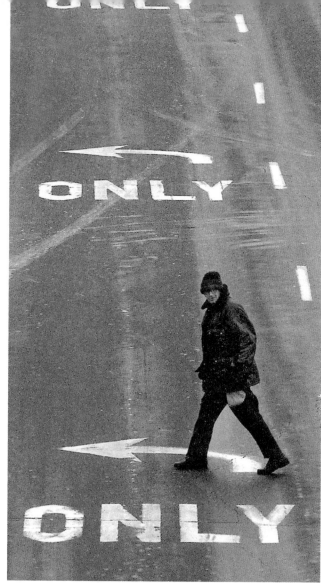

Morning Walk
July 2006

Dave Hoermann reads *The New York Times* as he leads a caravan that includes his children Zoe, on his back, Addison in the wagon, followed by the family dog, Mosley. The family was walking along Main Street in Homer.

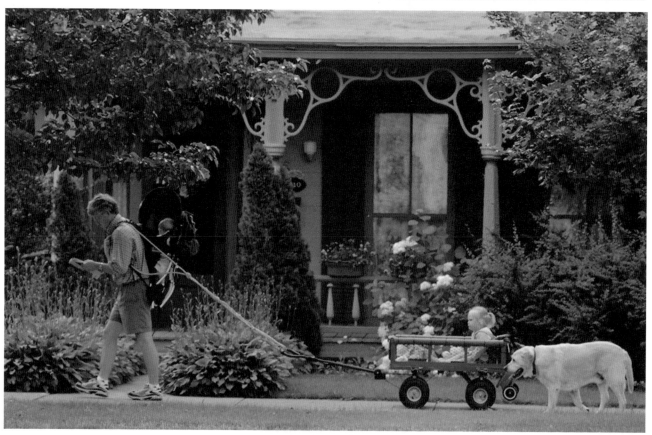

BOB ELLIS, Staff Photographer

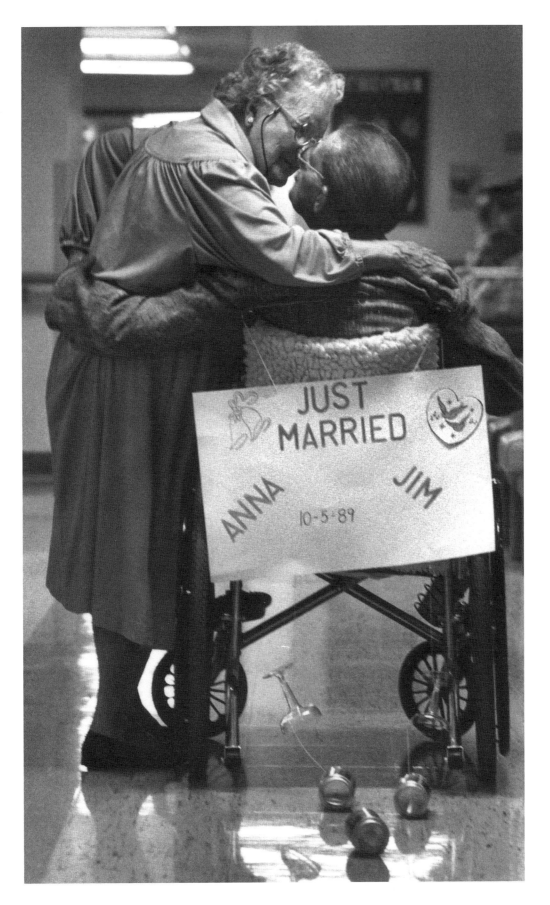

Just Married
October 5, 1989

The former Anna Schmutzler, 86, and James Short, 66, sneak a kiss following their wedding at the Groton Residential Care Facilty where they were both residents. Thirty residents attended the ceremony, held in the dining room. The couple originally met in the early 1930s but went on to lead their own lives until James moved into the facility in early 1989 where Anna was already a resident.

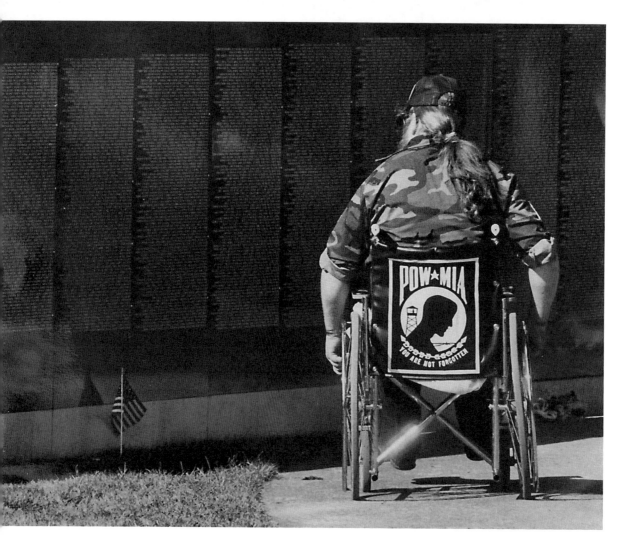

Moving Vietnam Wall
August 20, 1987

A Vietnam veteran looks at names on a traveling replica of the Viet Nam Memorial Wall in Courthouse Park.

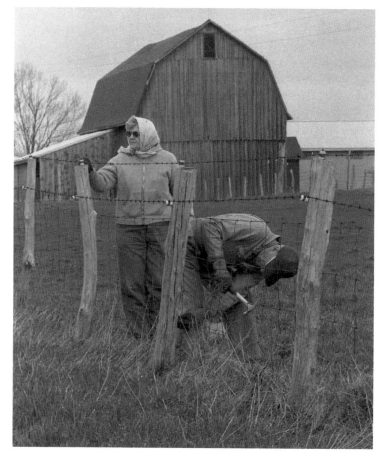

Mending Fences
March 17, 1987

Ted and Trixie Hulslander, work at mending their fence along Lake Road in Dryden.

BOB ELLIS, Staff Photographer

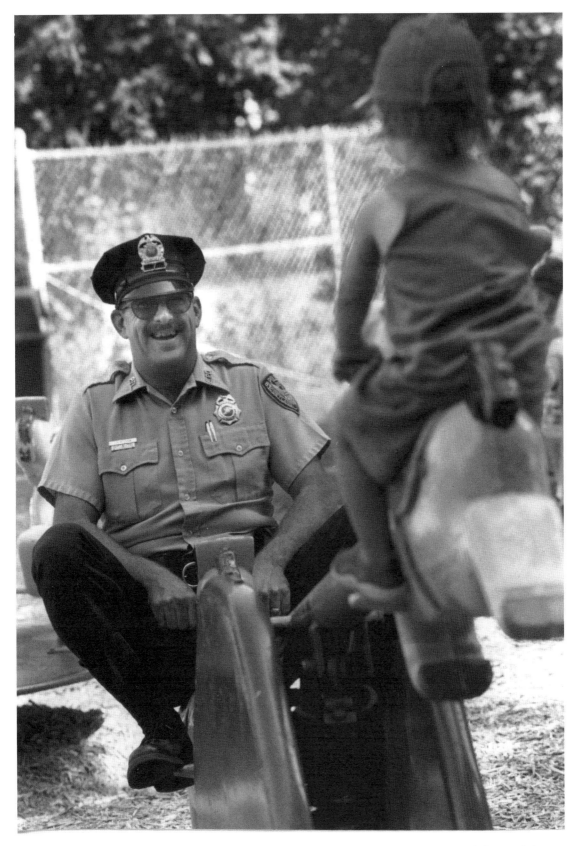

Teeter-Totter
August 31, 1999

Cortland police officer Jeff Nicoson rides the teeter-totter with Christian Pittsley on the Suggett Park playground. Nicoson was particpating in his department's Police-in-the-Parks program in which officers interact with children.

Photo won 3rd place in features category in the NPPA monthly clip contest

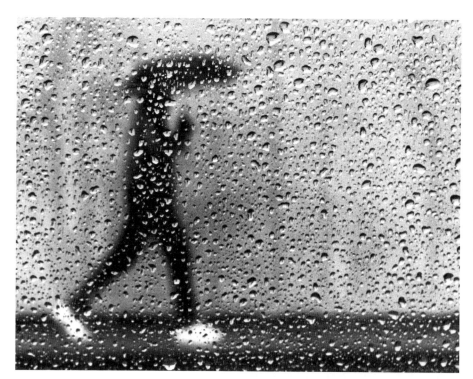

Rainy Day

A pedestrian walks in the rain along Orchard Street in Cortland during a downpour. (Shot from my drivers seat, focusing on the rain drops on the car window.)

Outhouse Santa
2001

Santa comes out of the outhouse after taking a break at the Hill of Beans Christmas tree farm on Chapman Road in the Town of Homer. Santa was there to greet those looking for a Christmas tree.

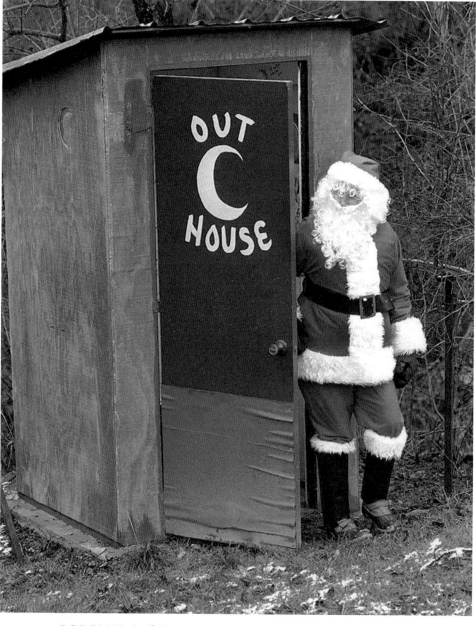

BOB ELLIS, Staff Photographer

Prom Players
May 30, 1995

Anna O'Shea, left, looks on as Beth Richardson drives to the basket against Sara Ellis during an impromptu basketball game. The three girls were waiting for their dates to arrive to take them to the Groton High School prom. Richardson and Ellis were members of the girls varstiy basketball team.

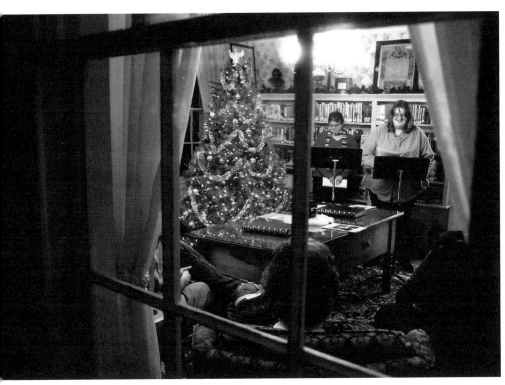

Poetry Night
December 5, 2006

McGraw High School senior Alyssa Whitney, right, recites poetry as classmate Katie Peak awaits her turn. The girls were just two of many on the poetry and musical program during the 7th Annual Poetry Night at Lamont Library in McGraw.

Shoveling the Roof
January 6, 1987

Fearful that heavy snow could weaken her porch roof, Edith Homer shovels it clear as her husband Darrell supervises from a second story window at their home on Groton Avenue in Cortland.

Photo won 3rd place in features category in 1987 New York State Associated Press Photo Contest

Willet Day Bungee
June 17, 2006

Heidi Sudbrink, 14, of Willet, leans forward while attached to a bungee cord while trying her luck on the Bungee Run at Willet's Day In The Park.

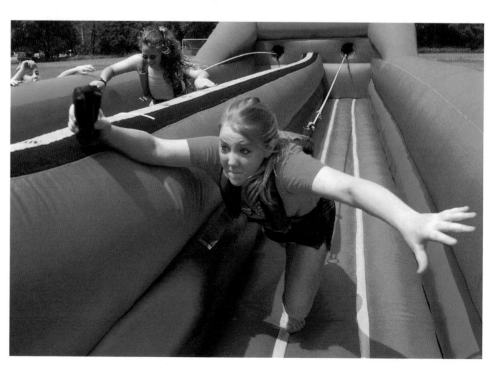

BOB ELLIS, Staff Photographer

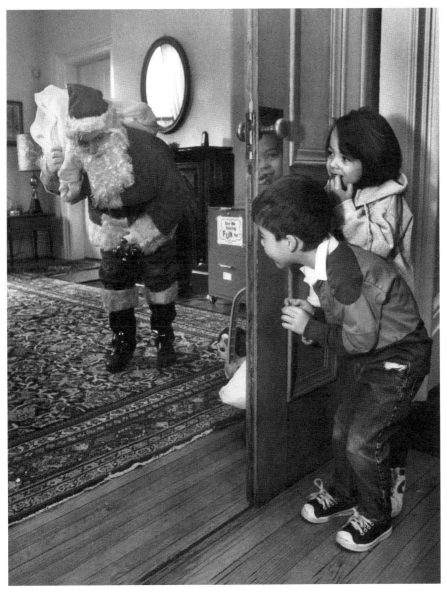

Here Comes Santa!
December 6, 1993

Vic and Meghan Marchetti, of Cortland, peek around a door, anticpating the arrival of Santa Claus at the Cortland YWCA.

Reflection
November 16, 1996

Greek Peak Ski Resort snowmakers are reflected in Chuck Bush's mirrored sunglasses as he watches his co-workers make snow on the slopes in anticipation of opening day.

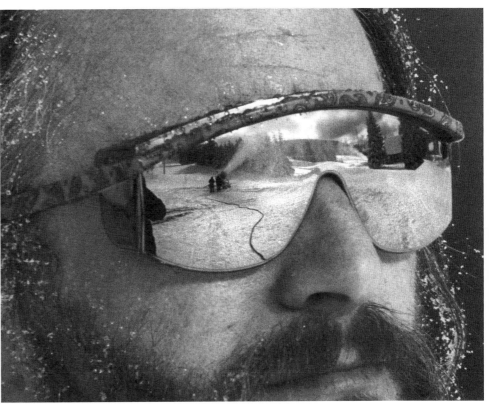

Candles
September 11, 2008

SUNY Cortland sophomore Stephanie Melendez, of Rockland County, is surrounded by flickering candles during a September 11th remembrance ceremony in front of Corey Union. Several hundred community members, students and staff attended the event.

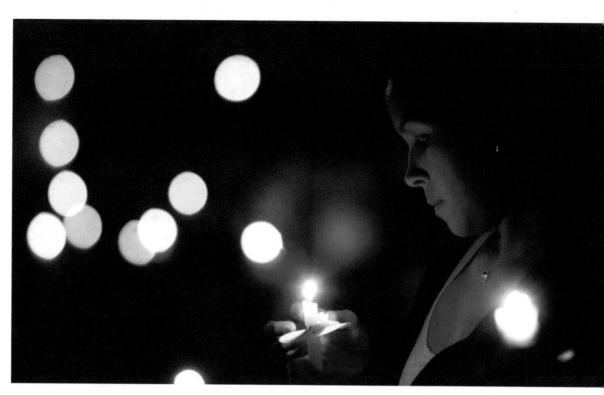

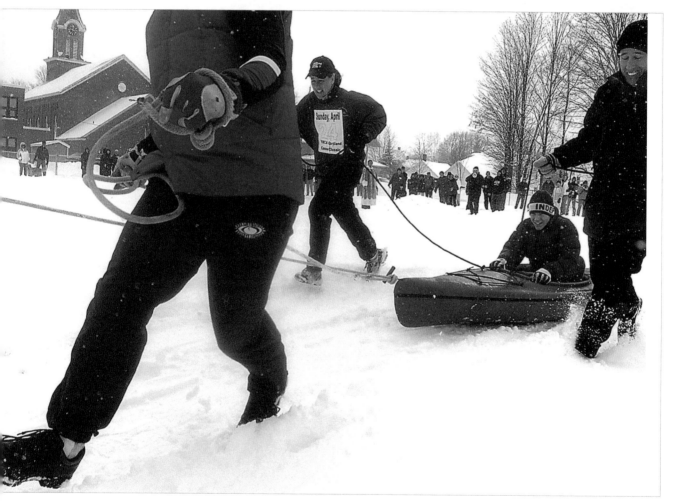

Human Dog Sled Race
February 12, 2005

The Cortland YMCA dog sled team race the course behind the Homer Elementary School in a kayak during the Homer Winterfest Human Dog Sled Race. Left to right are, the legs of Bob Vidulich, Aime Roberts, "driver" Mark Vidulich, and Brian Cummins.

BOB ELLIS, Staff Photographer

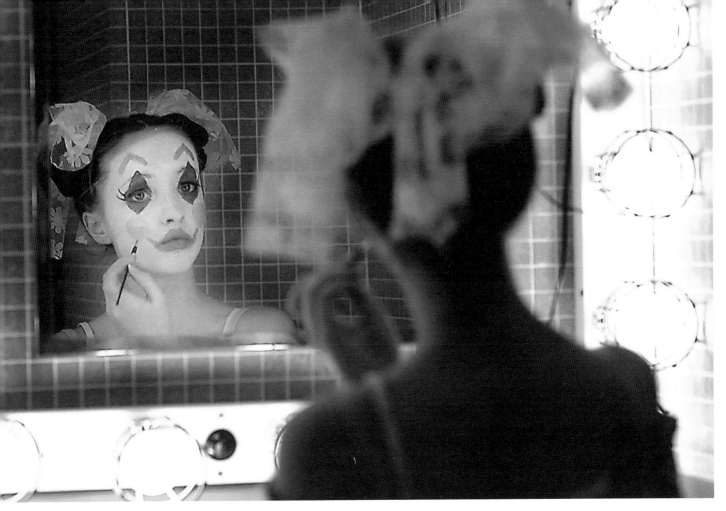

Ballerina Christine Foster applies makeup in the dressing room in Dowd Fine Arts Center on the SUNY Cortland campus. Foster was playing the Ballerina in a performance of The Nutcracker at the theater.

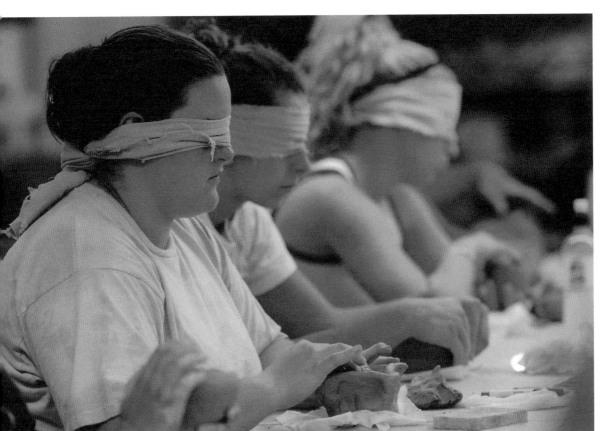

Pottery Class

Looking like a group of hostages, SUNY Cortland students wear blindfolds as they work clay without being able to see it during a pottery class in Old Main.

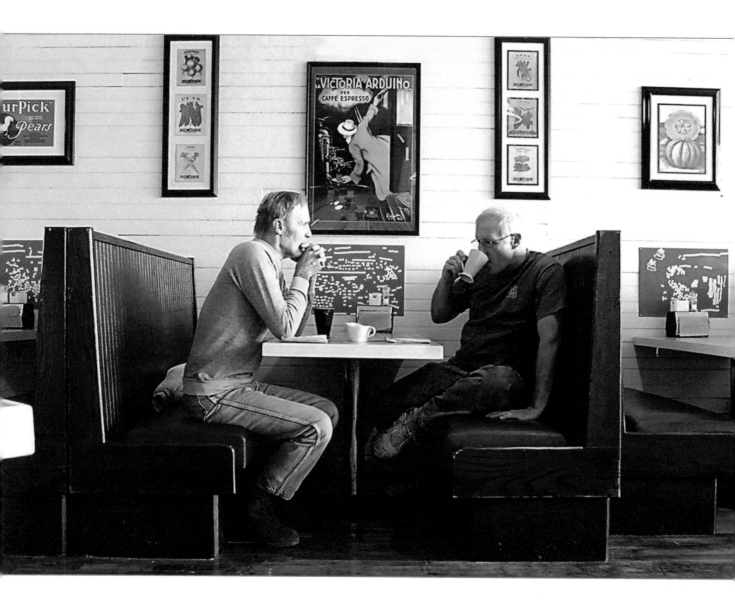

Red and White Café
November 2, 2008

William Covert, left, of DeRuyter, and Hart Seely, of Syracuse, take
time out for a cup of coffee at the Red & White Cafe in DeRuyter.

BOB ELLIS, Staff Photographer

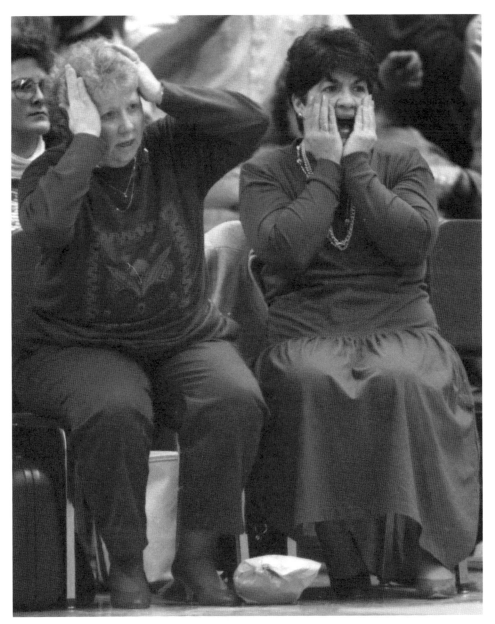

Wrestling Moms
January 3, 1991

Being a mother and having to watch your son wrestle can be an agonizing experience as Terry Stevens, left, and Toni Bossard can confirm. The two women were watching another wrestler at the time. Stevens is the mother of former Cortland High wrestler Kevin Stevens while Bossard's son, Ben Seamans wrestled on the school's junior varsity team.

Concert
December 17, 2008

First grader Stephen Gilbert checks out his fellow celloists while performing with the string ensemble during the annual St. Mary's School Christmas concert.

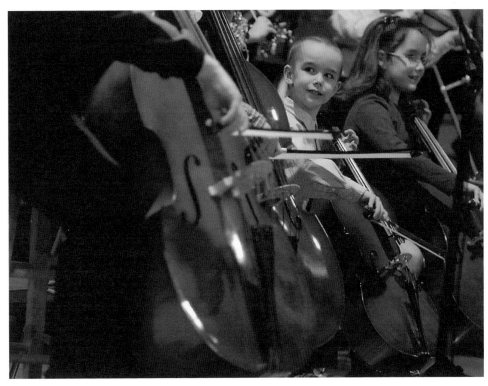

Heart-warming
February 12, 1988

St. Mary's School crossing guard Jan Bitondo wears a heart to celebrate Valentine's Day as she directs a student safely across Main Street in front of the school. Bitondo was known to dress up on various days such as S.t Patrick's Day, Halloween, and Christmas, as well as Valentine's Day.

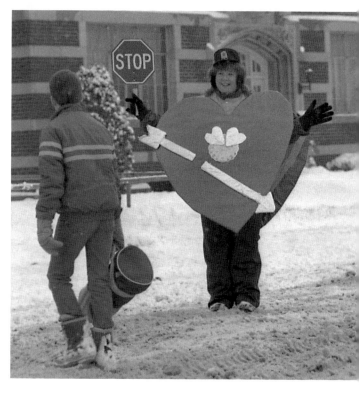

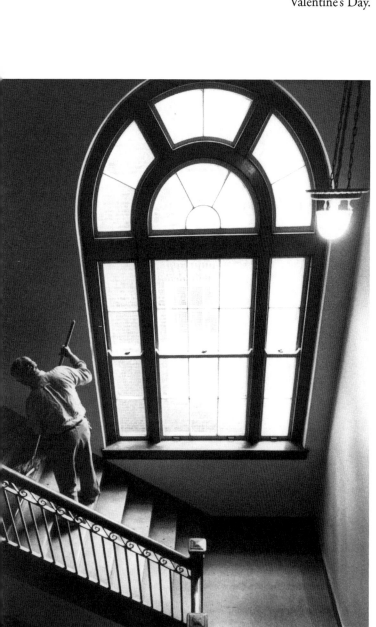

Morning Light
February 26, 1988

A large window provides Giovani DiPietro enough light to mop the stairwell in Old Main on the SUNY Cortland campus.

BOB ELLIS, Staff Photographer

KIDS

Like Art Linkletter said, "Kids say the darndest things." My job is to be there with a camera when they *do* the darndest things.

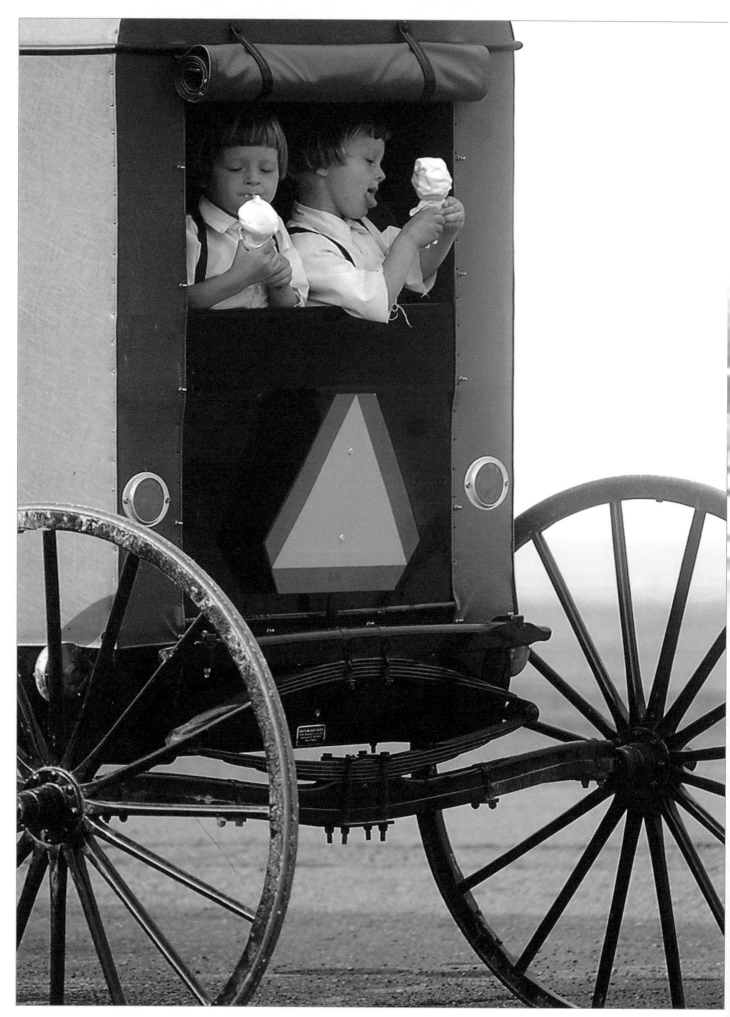

BOB ELLIS, Staff Photographer

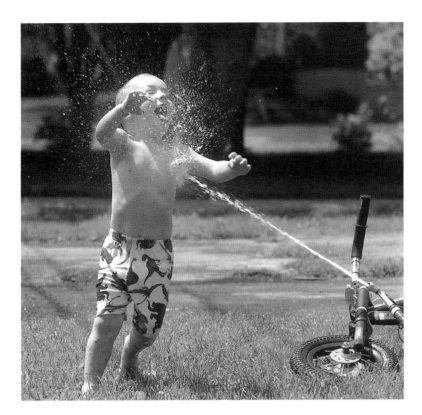

Gotcha!
July 17, 2006

Kamrin Scalzo, 2½, gets blasted as he runs through a stream of water from a garden hose in his front yard on East Academy Street in McGraw as temperatures reached into the nineties that day.

Foosball Eyes
June 27, 1990

Avery Quick of Dryden, cannot believe his eyes at a shot on goal while watching a foosball tournament at the YWCA Summer Care and Recreation program. Quick had already won his first round match.

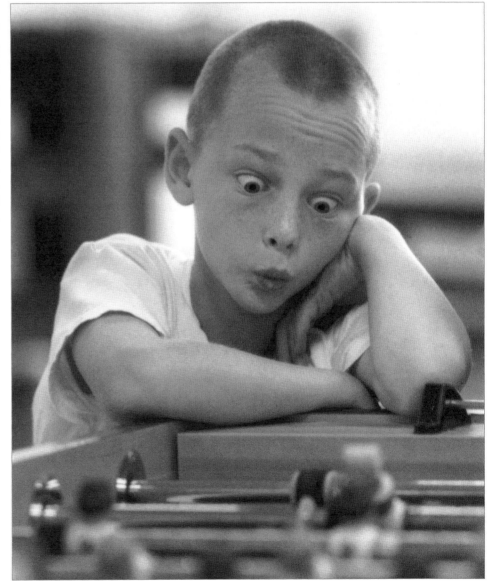

Ice Cream
July 20, 2006

Two Amish boys give loving glances to their ice cream cones. The boys were enjoying a night out in the family horse and buggy at Footie's Freez on Tompkins Street in Cortland.

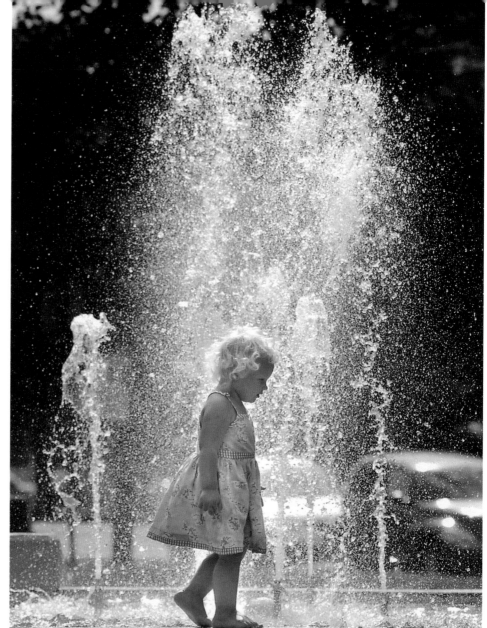

Fountain Walking
September 26, 2007

Two year old Tatiana Tarbox, of Dryden, walks around the fountain in Courthouse Park. Tatiana was visiting the park under the watchful eye of her grandmother.

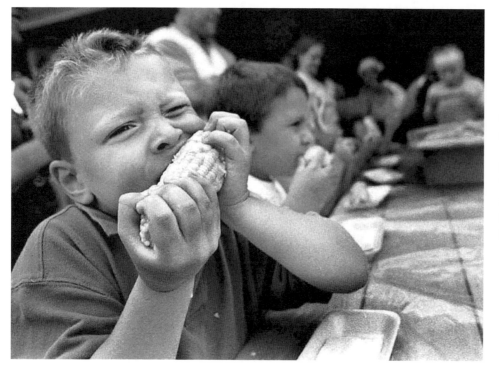

Corn Cob Eating Contest
August 2001

Despite having a loose tooth, Kyle Teeter, 6, of Cortland tears into an ear of corn during a corn eating contest at Anderson's Farm Market in Little York.

BOB ELLIS, Staff Photographer

Ball Boy on the Run
October 22, 2004

Ball boy Nate Cottrell runs the ball past Homer varsity football players on a Friday night during a ball exchange. Nate's dad, Tom, was an assistant coach with the team.

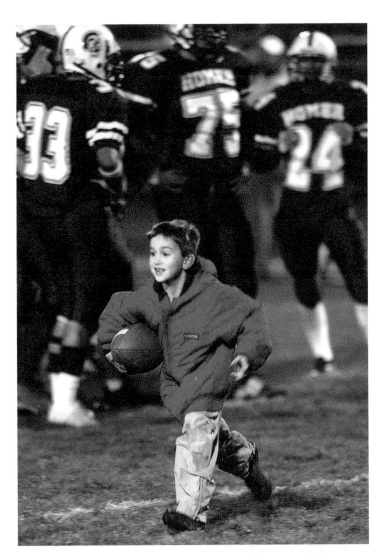

Little Ballerina
December 10, 2007

Angela Lang, 3, of Homer, watches a dress rehearsal of the Cortland City Ballet's production of The Nutcracker from the balcony at the Center For The Arts in Homer.

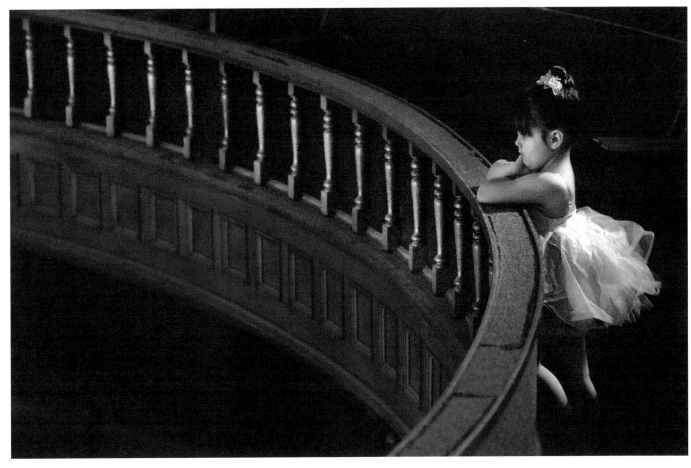

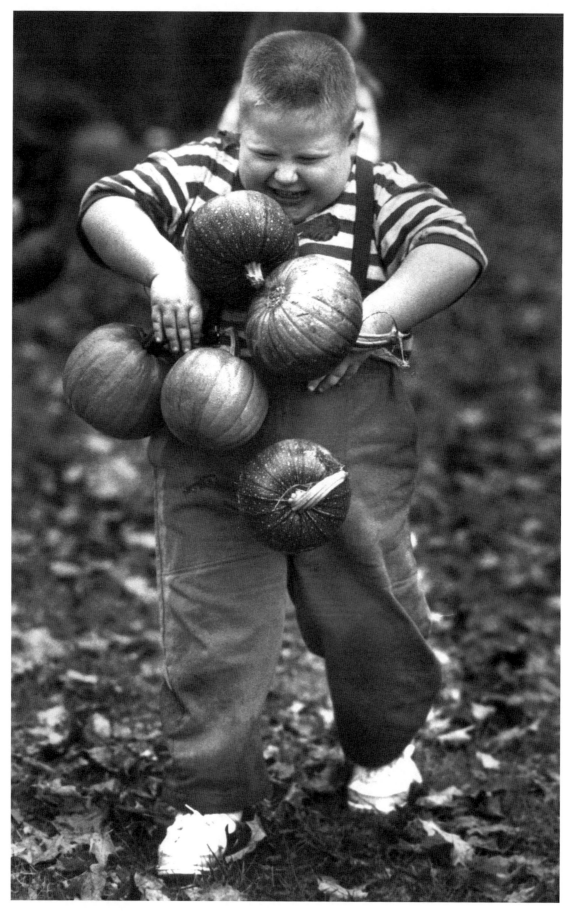

Dropping Pumpkins
January 15, 1990

Patrick McLorn, 4, of Cortland, drops his armful of pumpkins while attempting to carry them across the finish line. Patrick was participating in pumpkin games at Smith Gardens in Homer.

BOB ELLIS, Staff Photographer

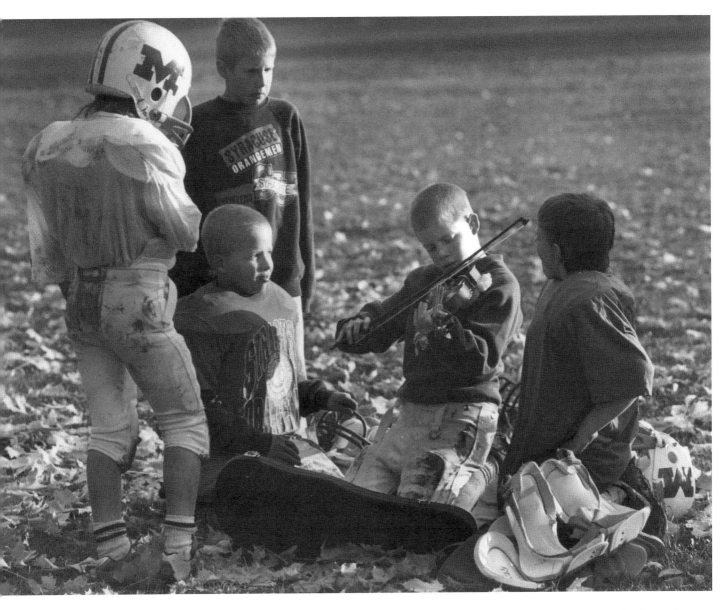

Football Violinist
November 5, 1993

Chris Nelson entertains his teammates with a rendition of "Twinkle, Twinkle, Little Star" on his violin following his Small Fry football practice at Suggett Park in Cortland.

Photo won 3rd place in features category in 1994 Associated Press Photo Contest

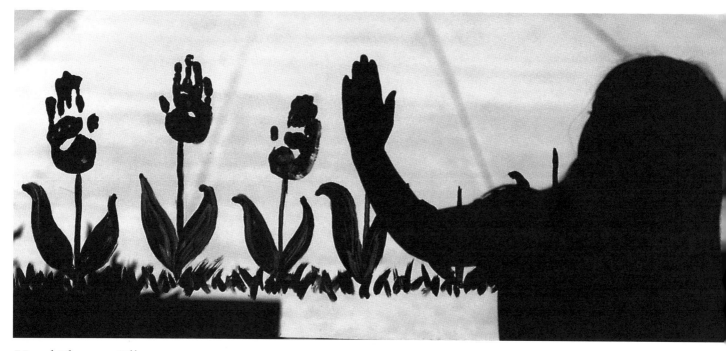

Hand Flowers Silhouette
March 19, 2006

Kali Oaks, a second grader at Smith School, uses her painted palm print to put flowers on top of their stems at the school.

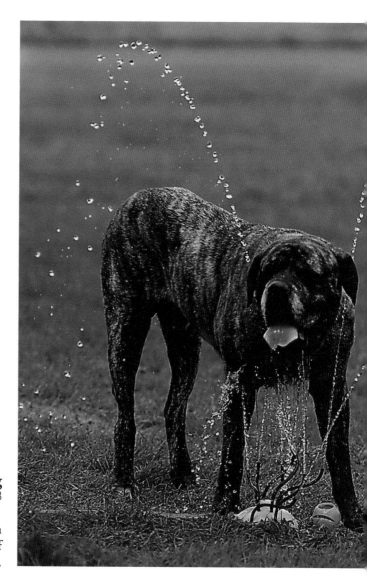

Hot Dog
August 5, 2008

Isaac Allen of Groton, cools off in his yard with his English Mastiff dog, Oscar, on a hot afternoon.

BOB ELLIS, Staff Photographer

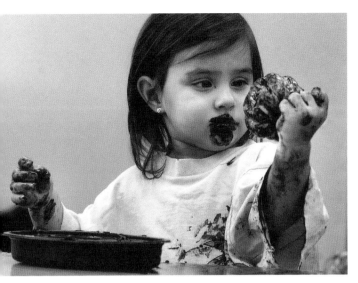

Messy Artist
October 28, 2005

Cynthia McDermott examines her paint job on a small pumpkin Friday during pumpkin painting at the Here We Grow Day Care Center.

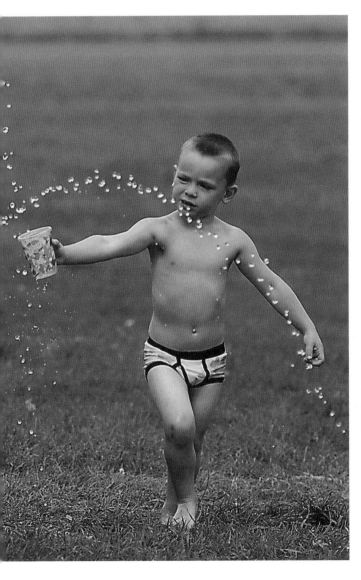

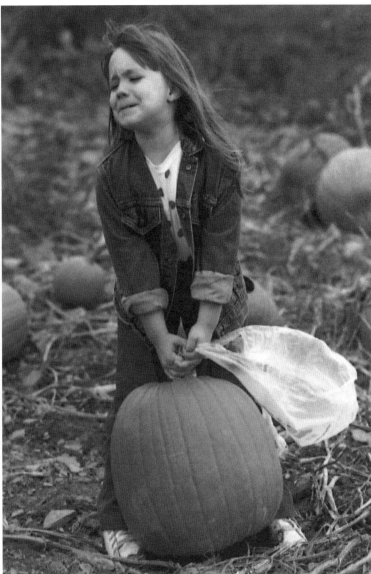

Heavy Pumpkin
October 19, 1990

Stacey Allen, a kindergartner at Homer Elementary School, finds this pumpkin a bit too heavy to carry while searching the pumpkin field at Anderson's Farm Market in Little York.

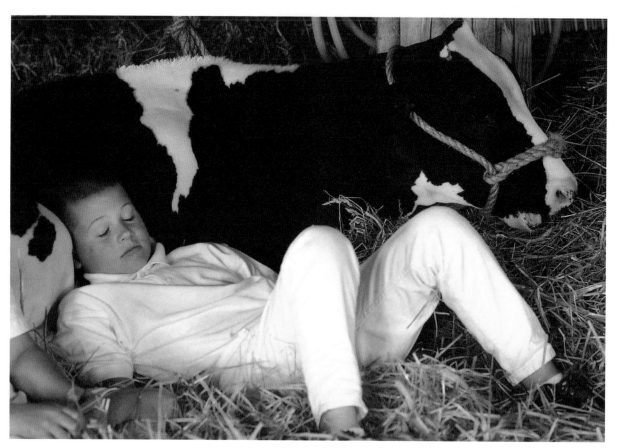

Jr. Fair
Break Time
July 14, 2003

Greg Masler of Cortlandville, takes a short break before the showmanship competition at the Cortland County Junior Fair.

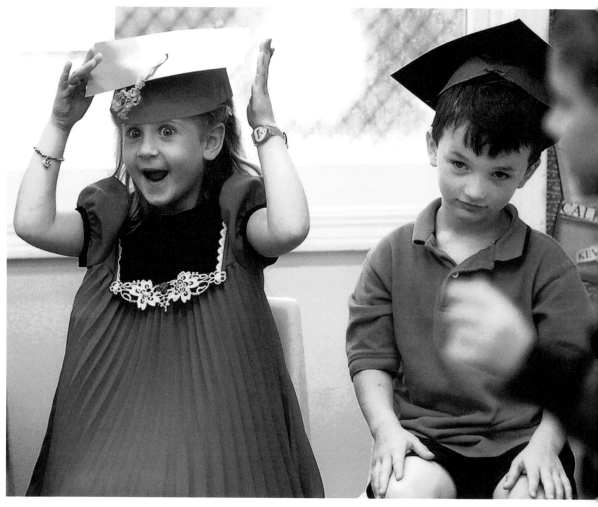

Graduation
Surprise
June 22, 2004

Catherine Jenks, works to keep her hat on as she and classmate Matthew Waibel watch fellow students receive their diplomas during the Here We Grow Day Care graduation ceremony.

BOB ELLIS, Staff Photographer

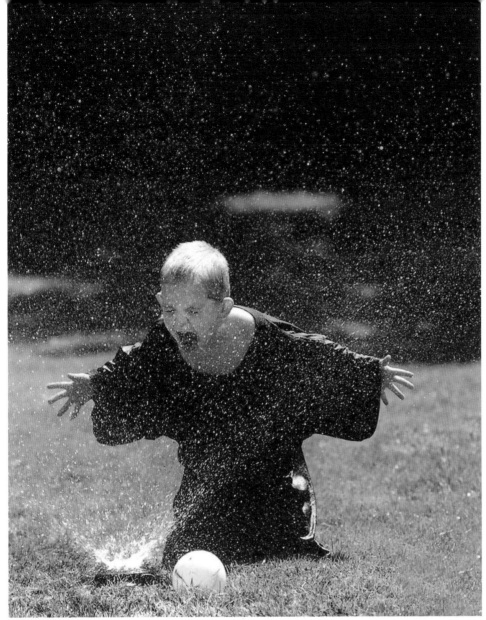

Staying Cool
July 31, 2007

Evan Sheedy of North Carolina, wears an oversized shirt as he stays cool while playing in a sprinkler in Dryden. Evan was in Dryden visiting his cousins.

First Day of School

Eustan Dilorio shows Kayla Sardella his name tag as he introduces himself on their first day of kindergarten at Randall Elementary School.

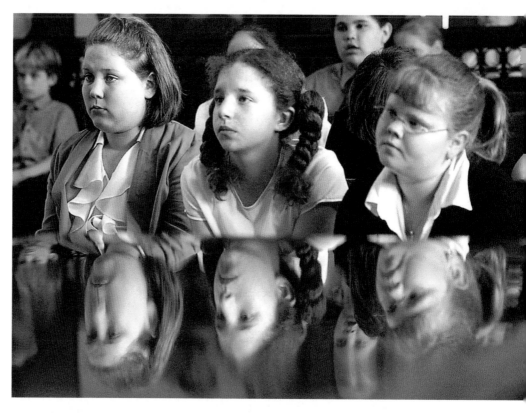

Reflections
June 3, 2004

Homer Intermediate School 5th grade " defense attorneys", left to right, Kristen Fuller, Jessica Conger, and Cassie Davis are reflected in the defense table as they listen to the Jurassic Park mock trial at the Cortland County Courthouse. The 5th grade classes of Janet Oechsle and Marv Zimmerman participated at the mock trail. Judge Philip Rumsey spoke to students about the importance of learning about the justice system.

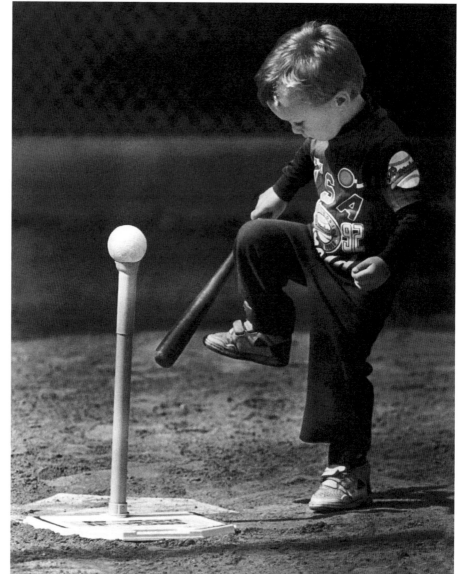

Dusting His Shoes
September 3, 1992

One of the first orders of business when you come to bat is to knock the dirt out of your spikes, or as Daniel Knopp says, "dusting your shoes". Daniel was playing tee-ball with his grandmother, Ginnie Knopp, at Dexter Park.

BOB ELLIS, Staff Photographer

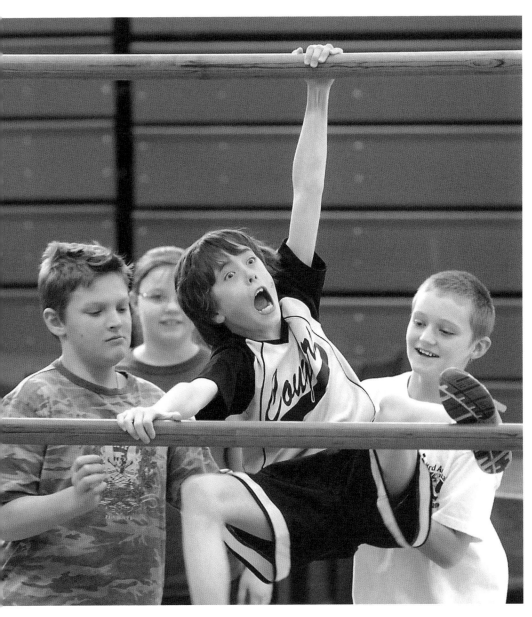

Hang in There
January 17, 2007

Fifth grader Kristian Reynolds hangs on while making a move on the uneven bars during his physical education class at Virgil Elementary School. Classmates, left to right, Paul Sabin, Samantha Brown and Jordan Smith lend their assistance. Students were learning gymnastics in the class.

I Can Do This!
June 7, 2006

Fourth grader Ashley Moss makes a face as she tries to keep marbles from falling while loading the machine while visting The Children's Museum at SUNY Cortland.

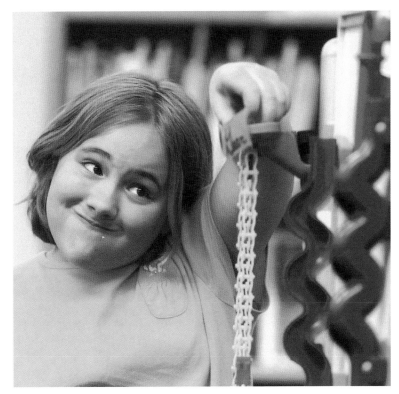

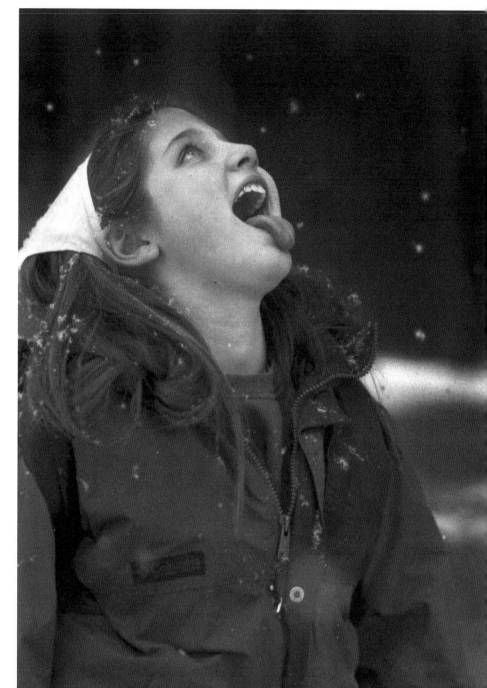

Snowflake Catch
January 6, 2001

Regina DiOrio tries catching snowflakes with her tongue outside Parker Elementary School. Regina, a third grader at the school, was waiting for her father to pick her up.

Photo won 3rd place in the Features category in the monthly National Press Photographers Association Region 2 photo competition.

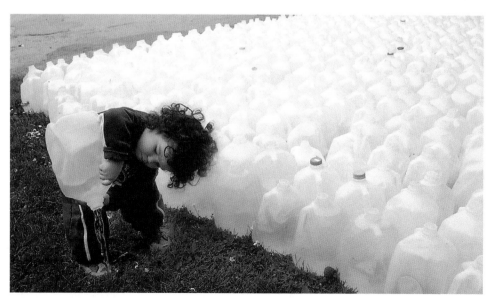

Waterfest
June 5, 2004

Nicholas Djafari, of Cortland, plays in the sea of gallon water jugs at the annual Waterfest held at the waterworks.

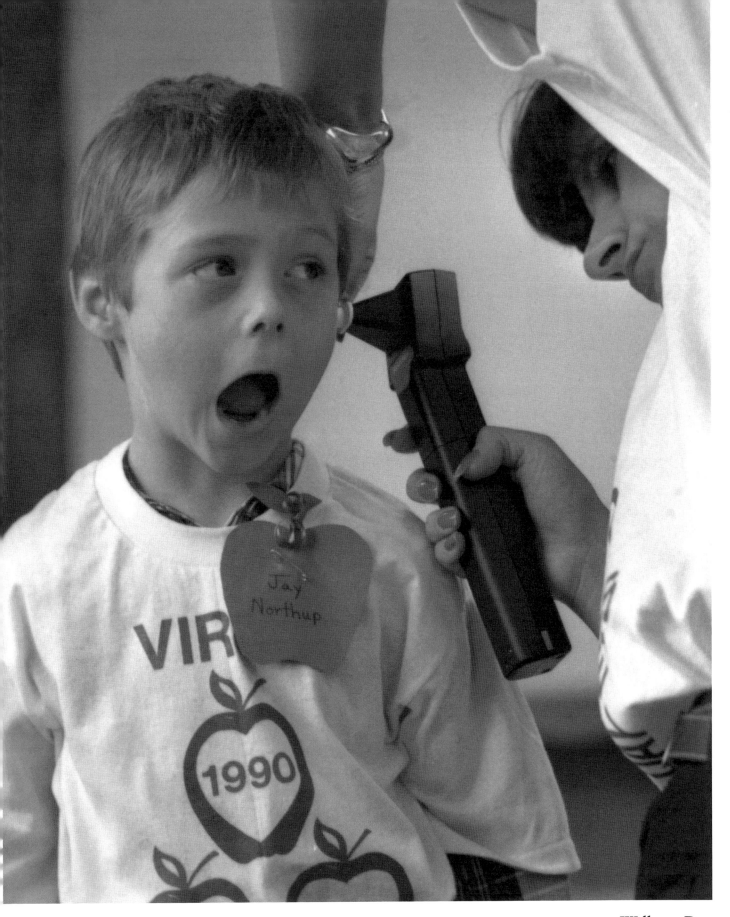

Wellness Day
October 27, 1990

Virgil Elementary School kindergartner Jay Northrup makes a face as speech
therapist Kathy Reynolds tests his ear drum during Wellness Day at the school.

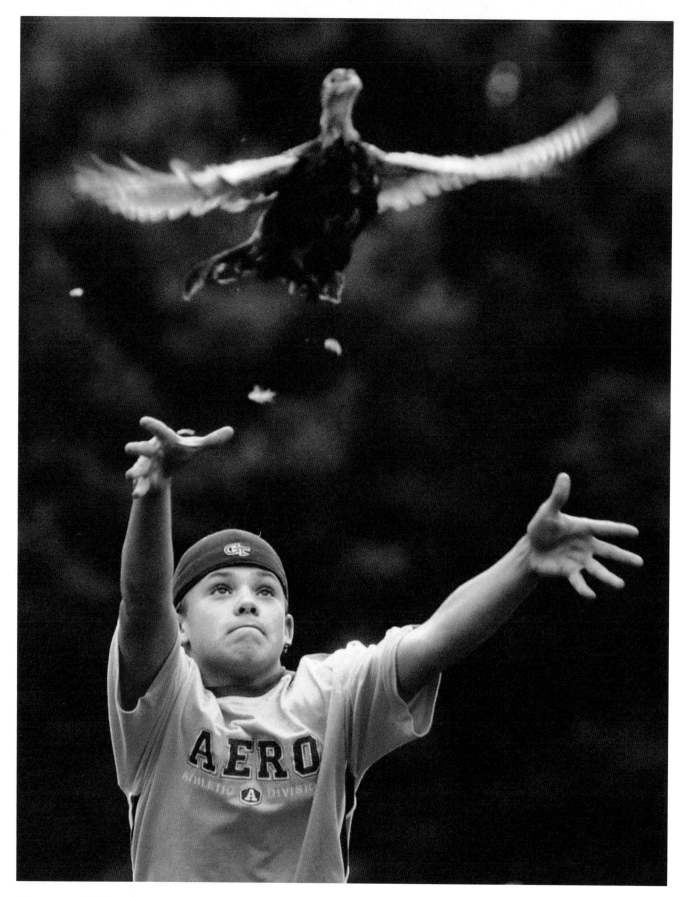

Pheasant Release
August 28, 2002

Brad Sustad, of Cincinnatus, releases a pheasant at the Izaak Walton League of America in Homer. Over one-hundred pheasants, raised at Camp Georgetown by the Cortland County Federation of Sportsmen, were released into the wild.

BOB ELLIS, Staff Photographer

Reindeer Music
December 18, 2001

CHS junior, Ryan Troy, sports reindeer antlers and nose while playing his violin with the Cortland String Orchestra at Cortland Care Center. Students in grades 7 through 12, along with a few alumni, performed holiday music at several locations around Cortland.

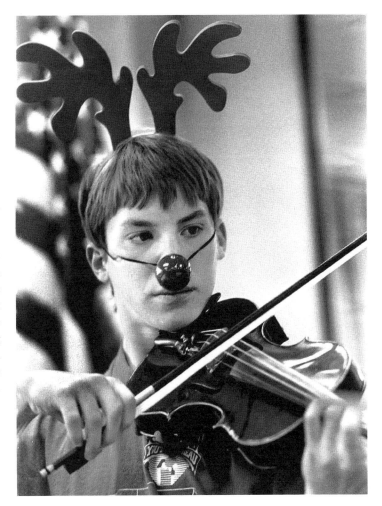

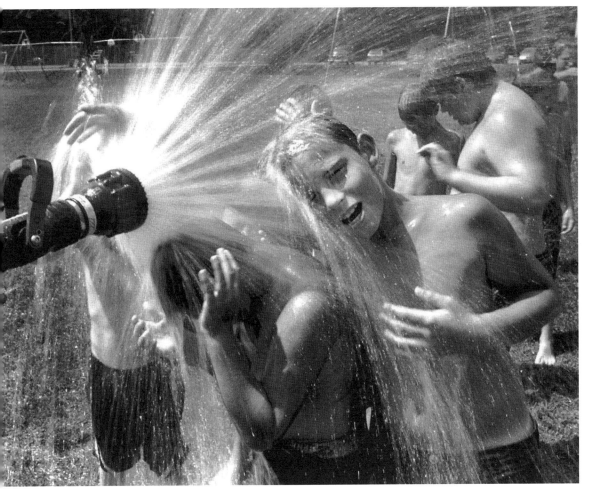

Hosed
August 8, 2001

With temperatures reaching the mid-90's, Ty Lynch cools off, courtesy of a McGraw Fire Department fire hose at Recreation Park in McGraw. Assistant chief Ed Greenman gave children a talk on fire safety and allowed them to tour the fire truck before spraying them with the hose.

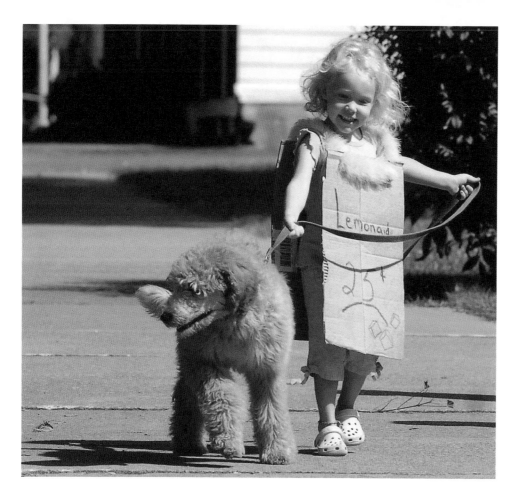

Lemonade Girl
August 24, 2006

Annika Roos of Homer, wears a sandwich board advertising 25 cent cups of lemonade as she walks with Elliot the poodle along Main Street in the village. Annika was wearing the sandwich board trying to drum up business for the neighborhood stand.

Surprise!
July 6, 1992

Lacey Cole gets a shocking surprise when she turned on the water at a fountain in Suggett Park in Cortland.

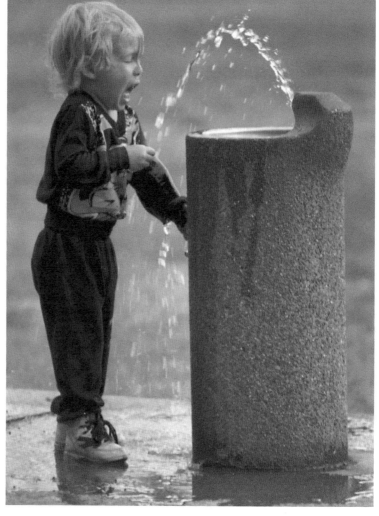

BOB ELLIS, Staff Photographer

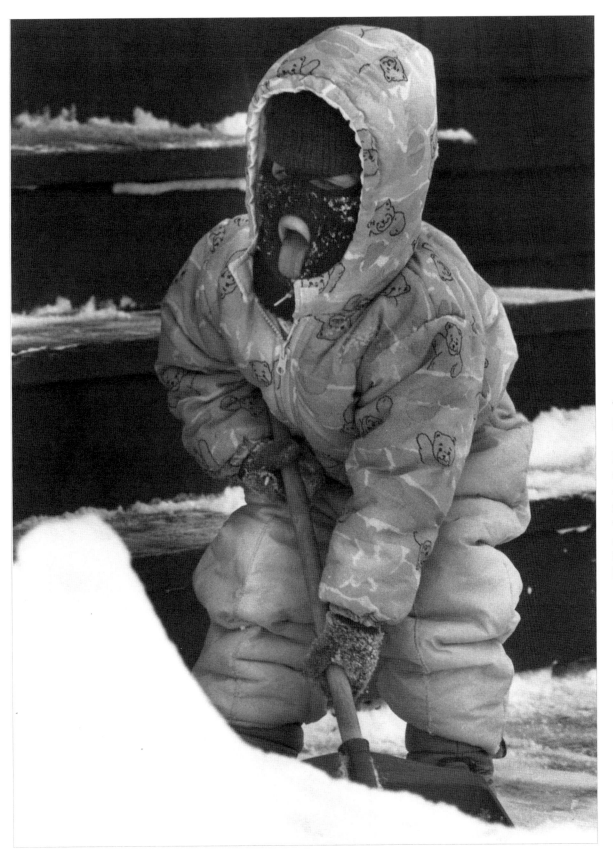

Tired Shoveler
February 8, 1988

Bridget Seamons appears to have had enough of shoveling for one day while working on the sidewalk in front of her William Street home in Cortland.

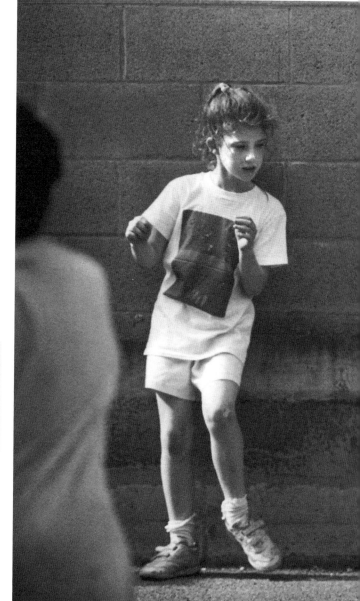

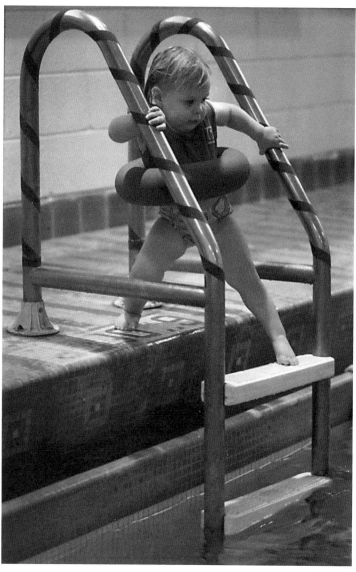

Testing the Waters
January 11, 1992

Amy Burgett of Tully, gingerly tests the ladder to the Cortland YWCA swimming pool. She was enjoying a morning swim with her mother, Cathy.

BOB ELLIS, Staff Photographer

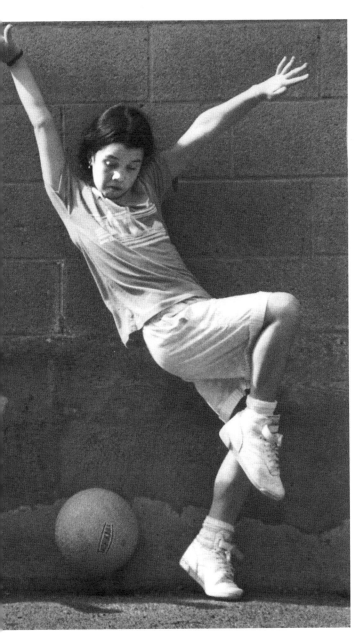

Dodgeball Dance
June 21, 1991

Chrissy Smith right, appears to be showing off a new dance step while trying to dodge a ball thrown by Mallory San Jule while playing in the St. Mary's school yard. Chrissy's sister Danielle looks on.

Photo won 1st place in feature category in NPPA monthly contest. Also, won 2nd place in features category in the 1991 Associated Press photo contest

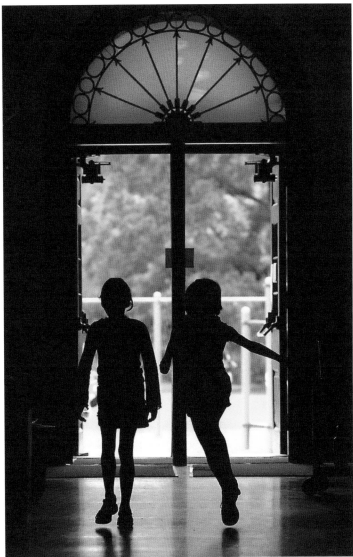

Last Day of School
June 23, 2006

Two students head for the door on the last day of school at Freeville Elementary School. Students were excused after a ceremony of lowering the American flag.

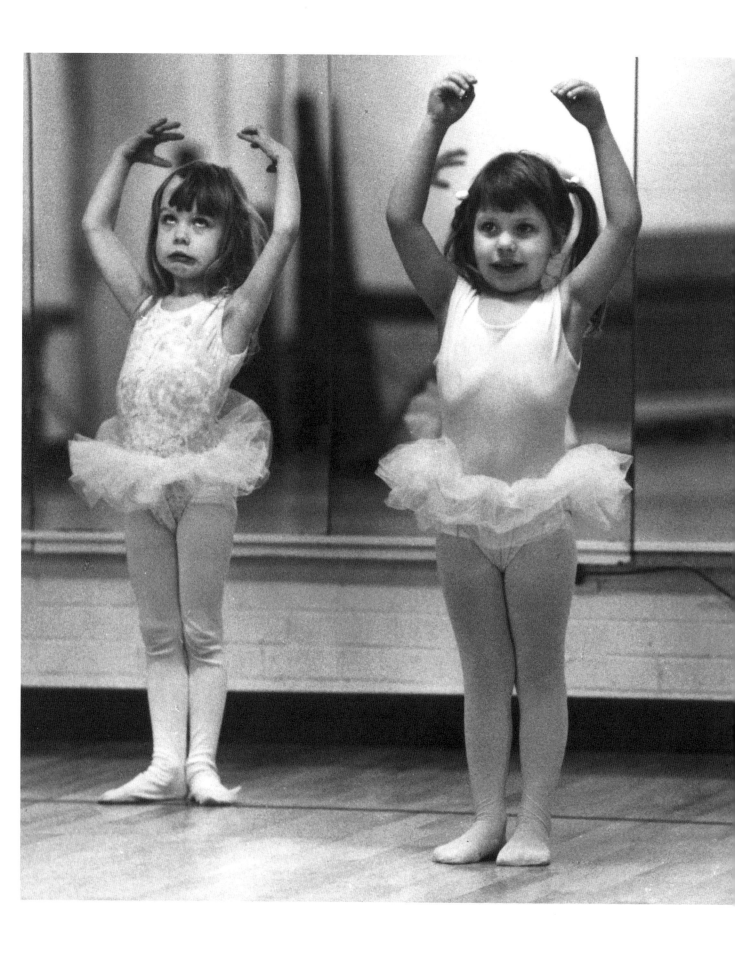

BOB ELLIS, Staff Photographer

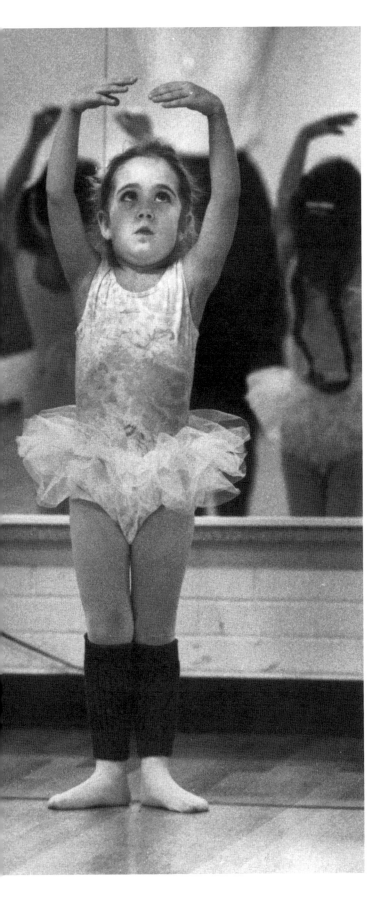

Dancers
January 11, 1991

Ballet dancers show varying degrees of concentration during a ballet class at the Cortland YWCA. Left to right is, Christine Wissink, Caylan Schneider, and Lisina Russo.

Won 2nd place in the feature category in 1991 Associated press Photo Contest

Practicing
March 1987

Dorothy Wang closes her eyes as she practices her violin at the Suzuki Violin School on Central Avenue.

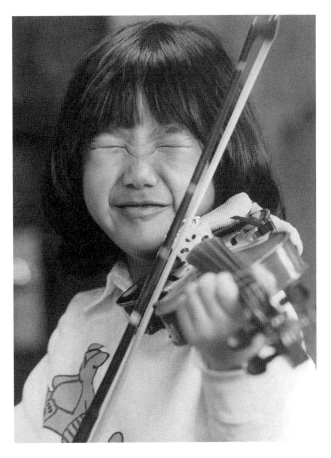

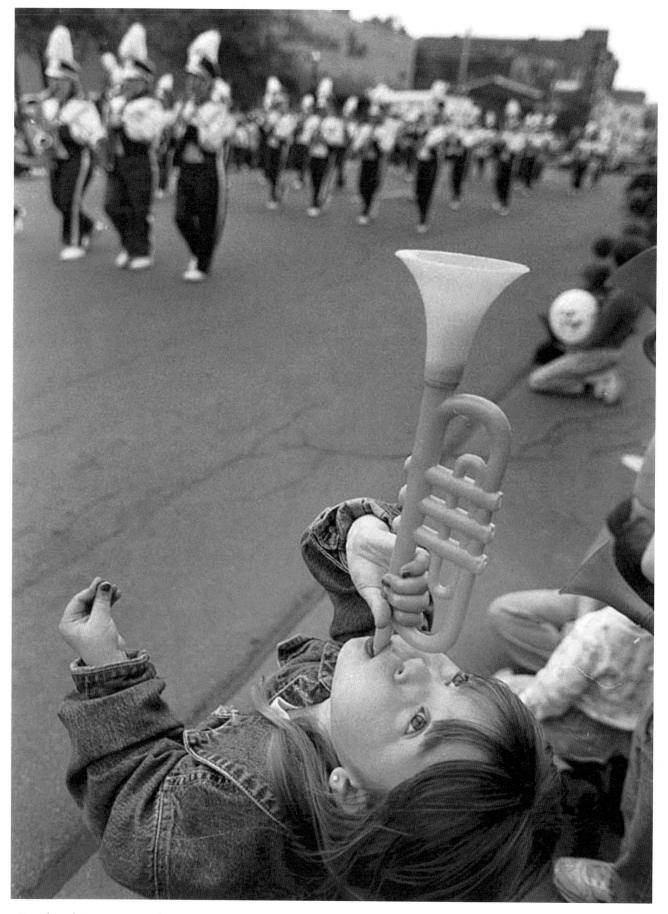

Cortland Dairy Parade
June 2001

Kelsey Neville, of McGraw, blows her own horn as the Homer marching band march by.

BOB ELLIS, Staff Photographer

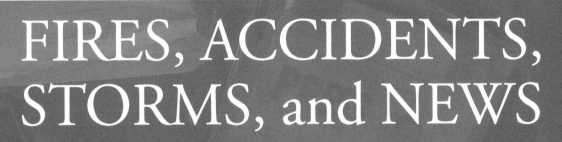

FIRES, ACCIDENTS, STORMS, and NEWS

Being a photojournalist means being there when news happens. These are the photographs that tear at my heart. Some are not always pleasant to shoot, but still part of my job.

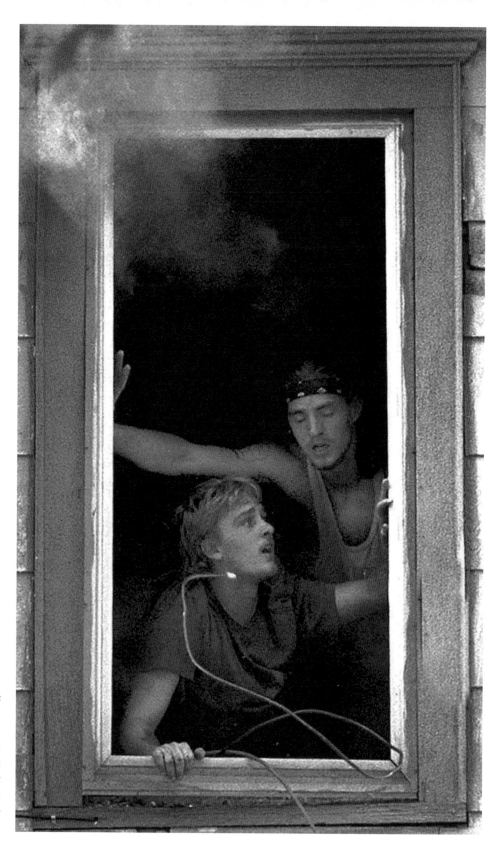

South Ave Fire
July 20, 2001

With smoke and flames closing in,
William Wright and Chuck Hopkins
battle of get out of a second floor
livingroom window during a fire
on South Ave. in Cortland. They
eventually lept to safety.

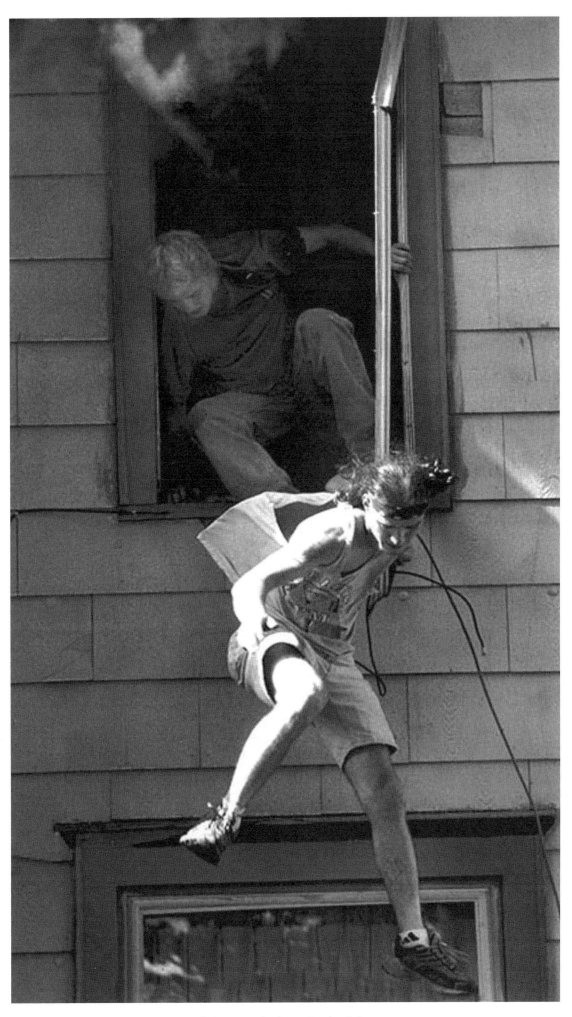

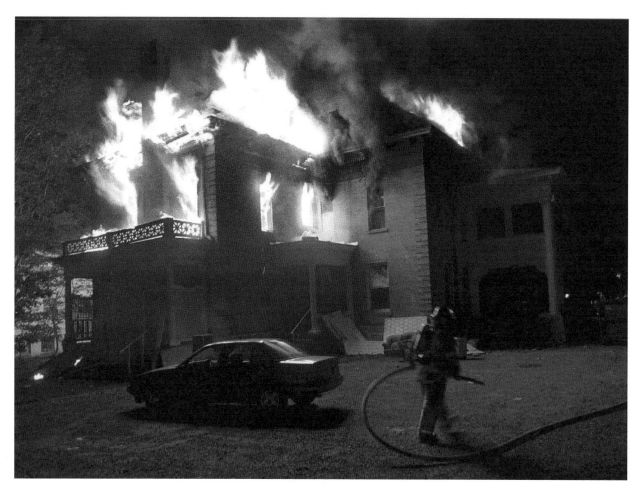

Pi Kappa Phi Fire
August 11, 2001

Cortland city firefighter David Jensen drags a hose to the rear of the Pi Kappa Phi fraternity house as flames shoot through the roof in early morning.

Barn Fire
July 23, 2005

A woman watches as flames engulf a Lake Road barn. Dryden, Freeville, Etna, McLean, Harford, Cortlandville, and Virgil were at the scene battling the fire which started in the early evening.

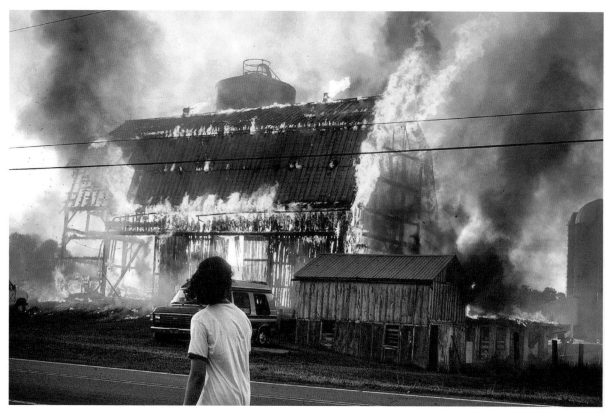

BOB ELLIS, Staff Photographer

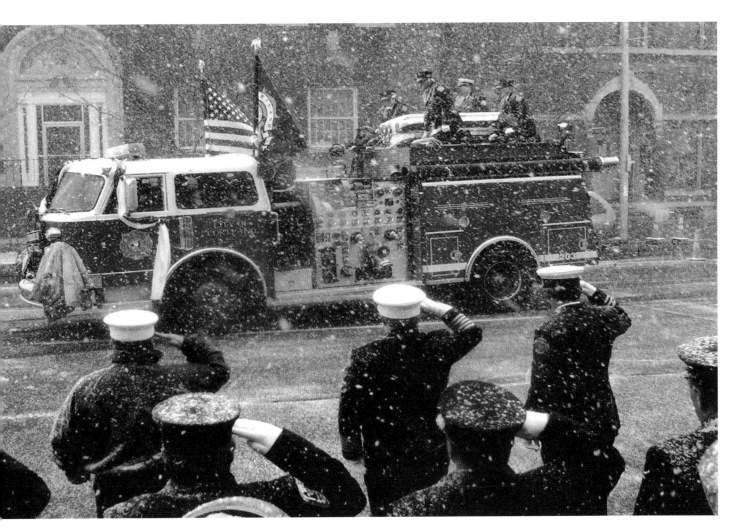

Cortland Fire Department Funeral
December 1, 2003

Despite a heavy snowfall, local fireman from Cortland, Cortlandville, and Homer, salute a truck carrying the coffin of Francis Treacy. Treacy was a 46 year member of the Excelsior Hook & Ladder Hose Company #3.

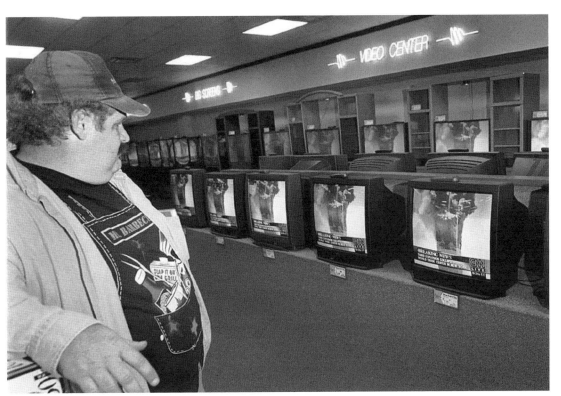

September 11th at Rex TV
September 11, 2001

Mark Besemer, a customer at Rex TV, watches the collapse of the World Trade Center North Tower live on CNN from the store.

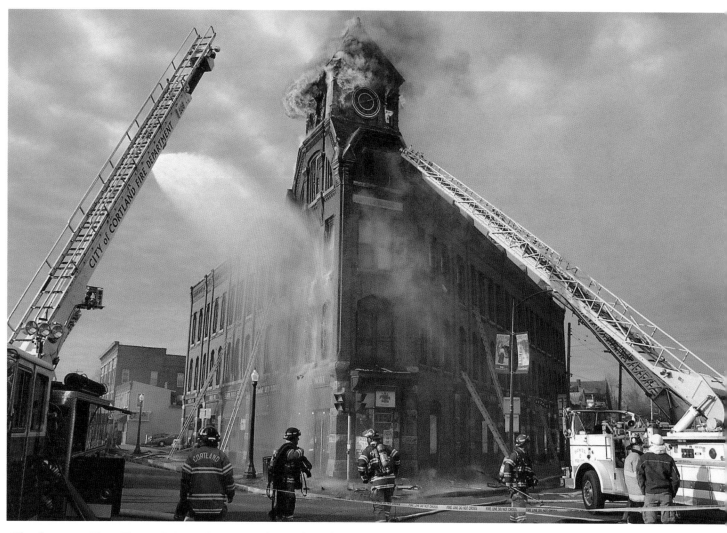

Clocktower Fire From Main Street
April 11, 2006

Flames shoot from the clocktower at the corner of Main and Tompkins Street.

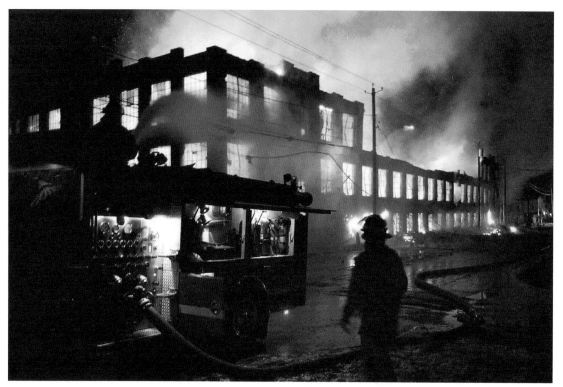

Wickwire Factory Fire
December 4, 2005

Cortland firefighters battle the Wickwire factory fire from the corner of Crawford and South Main.

BOB ELLIS, Staff Photographer

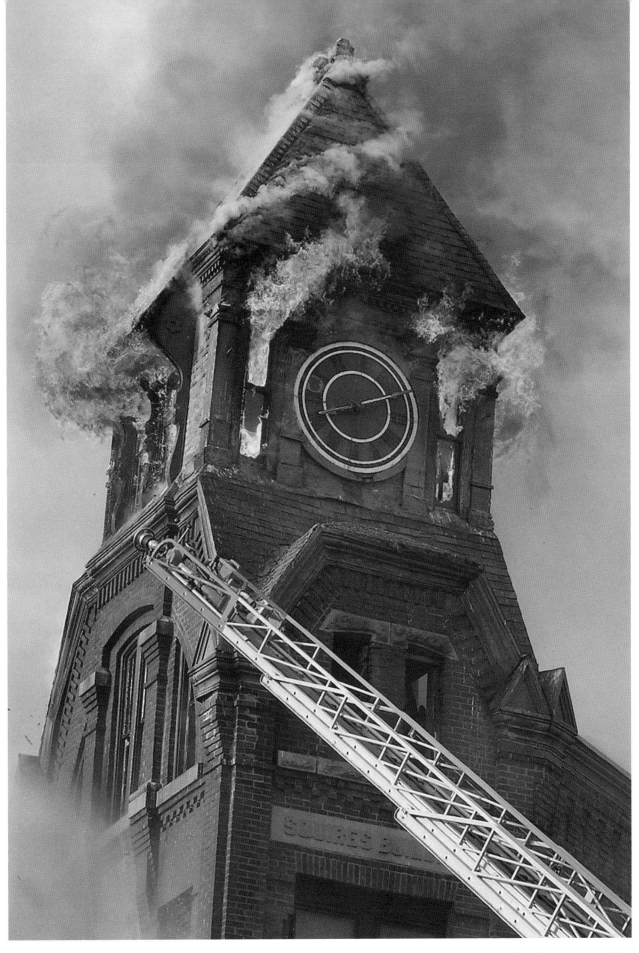

Clocktower on Fire
April 11, 2006

Flames shoot from the clocktower at the corner of Main and Tompkins Street.

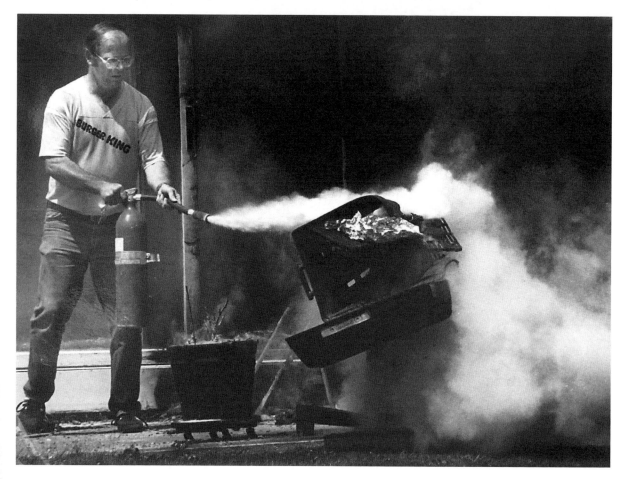

Burger King

Homer Fire Department Chief Don Butler wears an appropriate Burger King shirt as he extinguishes a grill fire on Cortland Street in Homer.

Flood
July 28, 2006

Village of McGraw DPW superintendent Andy Chavoustie talks on his cell phone at the corner of East Academy and Spring Streets where water from Trout Brook goes over the bridge.

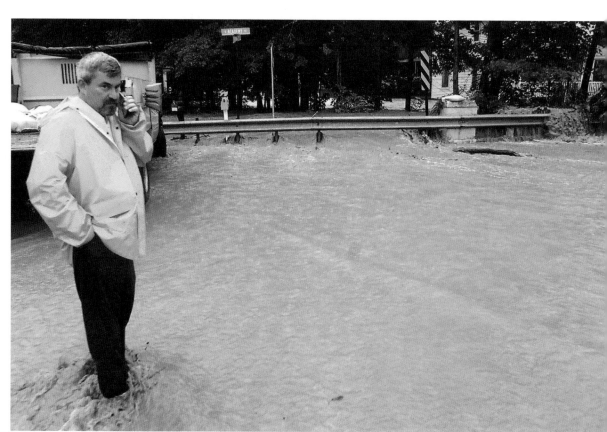

BOB ELLIS, Staff Photographer

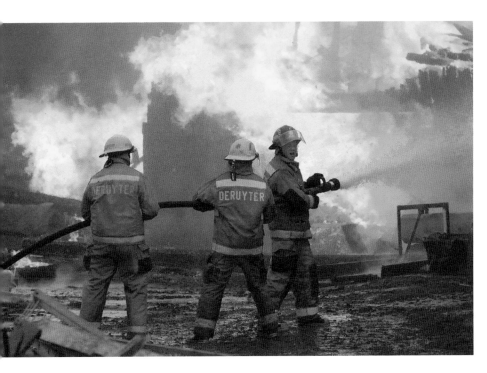

Crains Mills Fire
April 13, 2007

DeRuyter fiefighters battle intense flames from a Crains Mills Road barn fire in Truxton. The barn was a total loss.

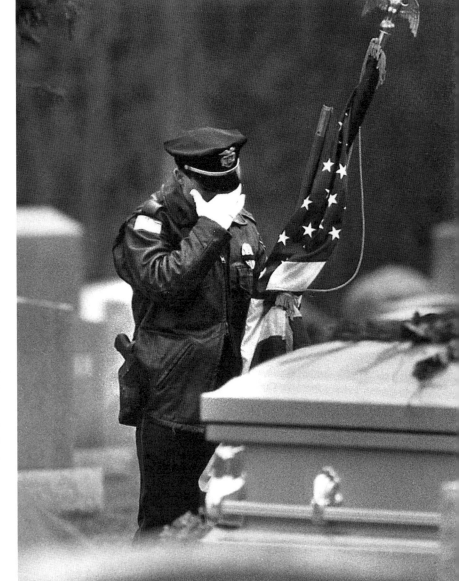

Saying Goodbye
November 22, 1996

Don Barker, an Ithaca police officer and member of the color guard unit, pays his last respects to Michael Padula at Calvary Cemetery in Ithaca. The ceremony had ended and Barker was among the last to leave. Padula was killed in the line of duty.

Cortland County Says "NO" to Nuclear Dumping

In December of 1988 The New York State Low-Level Radioactive Waste Siting Commission announced ten areas statewide for potential waste dump sites, six of them located in Cortland County. The following photos show residents of Taylor, New York, and other towns within the county waging a seven-year battle against the commission with a passion I had never seen before.

Residents of every age and background became one against the proposed sites, greeting the commission members with anger and frustration. I covered these meetings from the dead of winter to hot summer days and came to the conclusion that New York State would need to bring in the National Guard before the people of Cortland County would allow such a site to be built. It was inspiring to see the passion and love these people had for their land.

Finally in March of 1995, after seven years of confrontations, the new Governor, George Pataki, realized the futility of the Commission and disbanded it. The people of Cortland County had won.

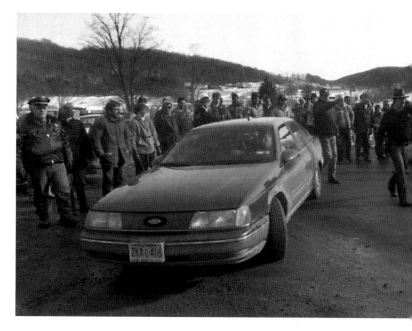

Turned Around
January 20, 1990

Lt. Chauncey Bennett, left, Lt. Robert Churchill and Sgt. Harold Peacock, of the Cortland County Sheriff's Department show New York State siting commission officials the way out at the intersection of Taylor Valley and Hawley Woods Roads in Taylor after protesters successfully blocked their planned visit to the Allen farm in Taylor. Protesters cheered as the car left via Hawley Woods Road.

Yelling at Dunkleberger
December 13, 1989

Neal Merkley, center and Al Sweet, right, join other protesters in yelling at New York State low-level nuclear waste dump siting commission executive director Jay Dunkleberger during his walk over the proposed site in Taylor.

BOB ELLIS, Staff Photographer

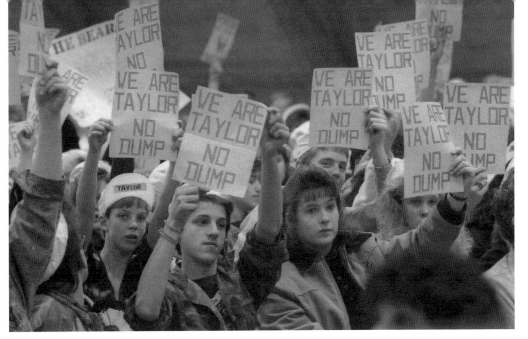

Student Protesters
November 16, 1989

Cincinnatus Central School students attend a public hearing on the proposed low-level radioactive dump in Taylor armed with plenty of anti-dump signs as they jeered the state siting commission at Lusk Field House on the SUNY Cortland campus.

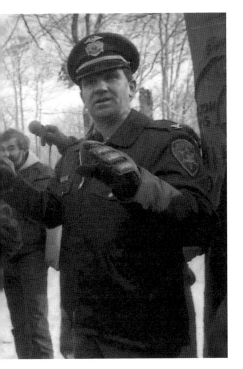

Protesters with Lee Price
December 13, 1989

Cortland County Undersheriff Lee Price advises anti-nuclear dump protesters to leave the area on Jordan Road in Taylor where New York State wants to site a low-level nuclear dump. Most left the area, however thirteen protesters were arrested.

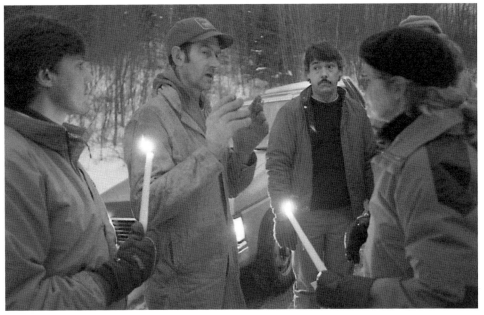

Protesters with Art Allen
January 16, 1990

Taylor landowner Art Allen, center, tells anti-nuclear dump protesters on Allen Hill Road that he will require them to sign a waiver before they will be allowed on his property when state technicians come to evaluate his farmland for a low-level nuclear waste dump. New York State reportedly offered Allen one million dollars for his farm to site the dump.

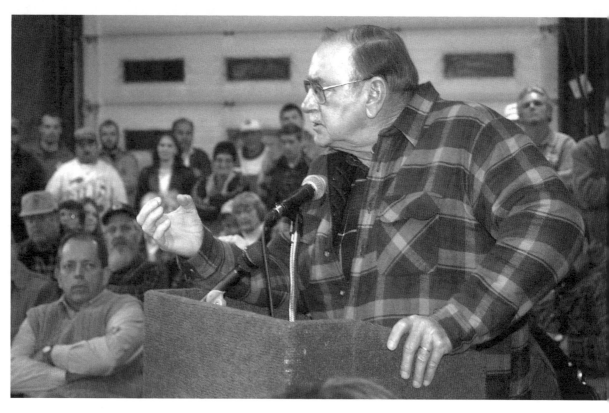

Cuyler Town Meeting
November 7, 2002

An angry Bob Denkenburger addresses the Cuyler Town Board in the packed Town of Cuyler Highway garage.

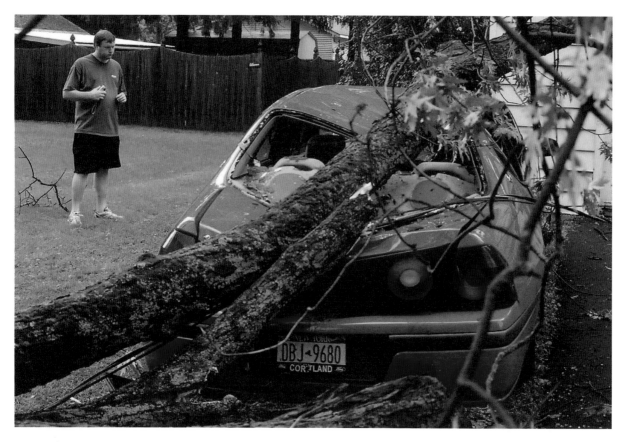

A Violent Storm
August 18, 2008

Mike Buchalla, of Evergreen Street in Cortland, looks over his crushed Monte Carlo in his driveway. A quick and violent storm passed through Cortland knocking a tree onto his car and house.

BOB ELLIS, Staff Photographer

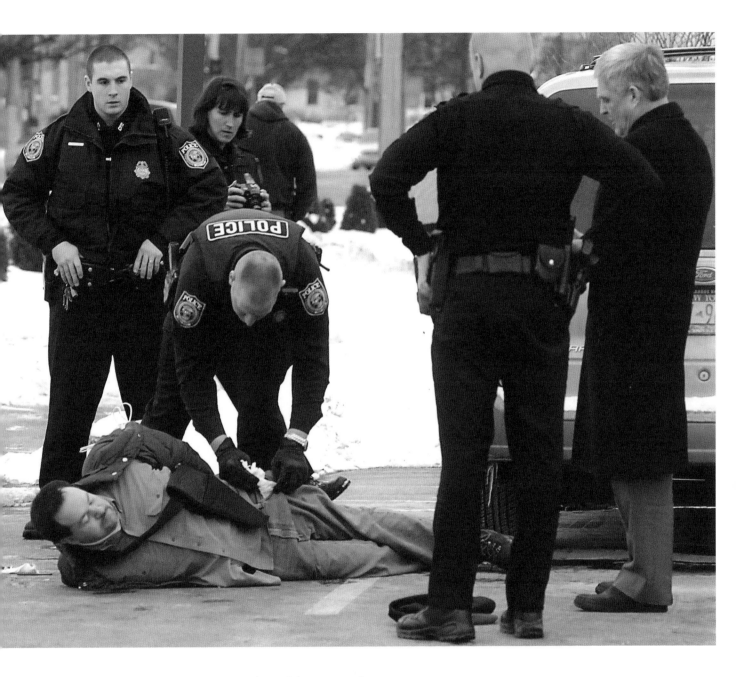

Bank Robber Caught
February 1, 2007

Cortland Police Department officer Chad Hines searches the pockets of a
bank robbery suspect in the parking lot of Tompkins Trust Company branch
office at the corner of Church St. and Clinton Ave. Looking on are, left
to right, Cortland Police Department officer Ben Locke, Cortland Police
Department Sgt. Liz Starr, Cortland County Sheriff's Department officer
Mark Strom, and Cortland Police Department detective Sgt Rick Troyer.

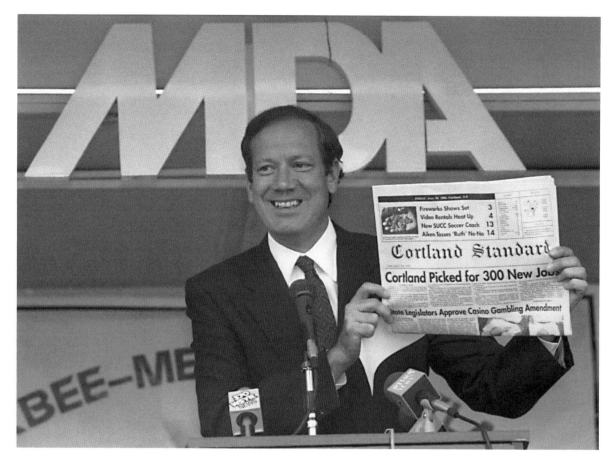

Pataki Visits Cortland
June 30, 1995

New York State governor George Pataki holds up a copy of the Cortland Standard duing his Cortland press conference where he announced the creation of three hundred jobs when Buckbee-Mears picked Cortland to build a large addition to their local factory.

Spilled Lumber
October 28, 2004

Workers from Bestway, on Luker Road, clean up lumber that spilled from a tractor trailer in front of the A&W Resturaunt. The Cortland County Sheriffs Department and NYSP were at the scene investigating the cause of the spill.

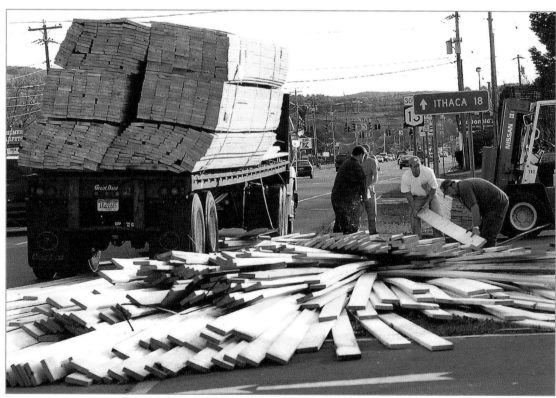

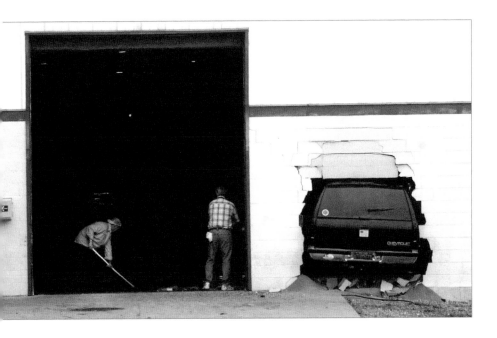

Missed by That Much
July 18, 2005

Marietta Corporation workers clean up the mess after a pickup truck slammed through their factory on Central Ave. The driver failed to negotiate a right turn onto Hubbard St. and went straight into the building.

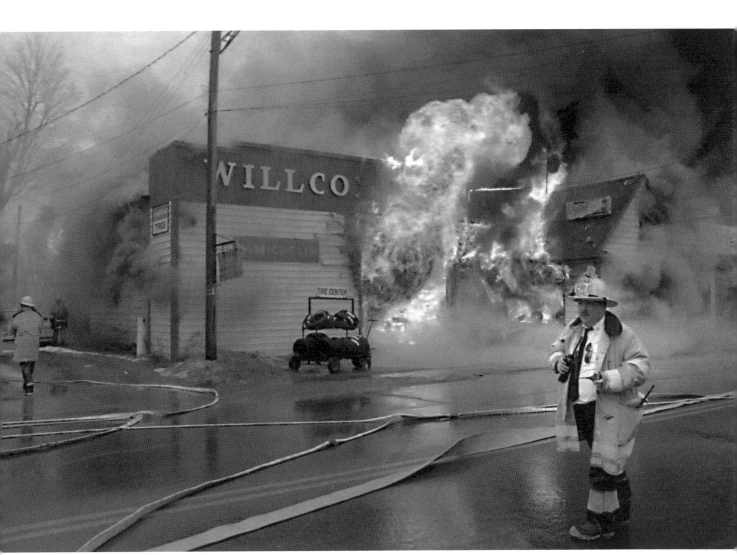

Wilcox Tire Fire
January 10, 1990

Cortland Fire Chief Dennis Baron gives orders from Port Watson Street as Willcox Tire and Muffler goes up in flames.

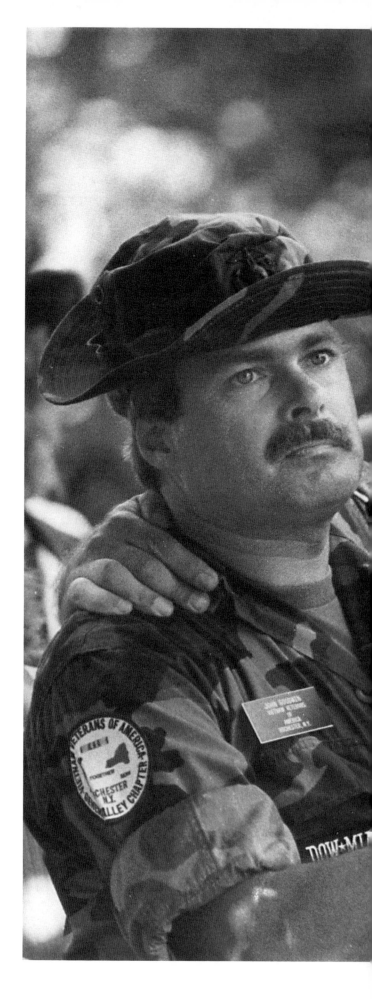

Vietnam Vets
1988

Vietnam veterans, left to right, John Goodwin, John Freibergerm and Arnie White, along with White's wife Kathy, all from Rochester, listen to an emotional speech during a Memorial Service in Courthouse Park. Vietnam and other vets gathered to cap off a week where a portable Vietnam Memorial Wall replica was on display.

Photo won the Bernard Kolenberg Memorial Award as the best spot news photograph and Best of Show Award in the 1988 Associated Press Photo Contest.

BOB ELLIS, Staff Photographer

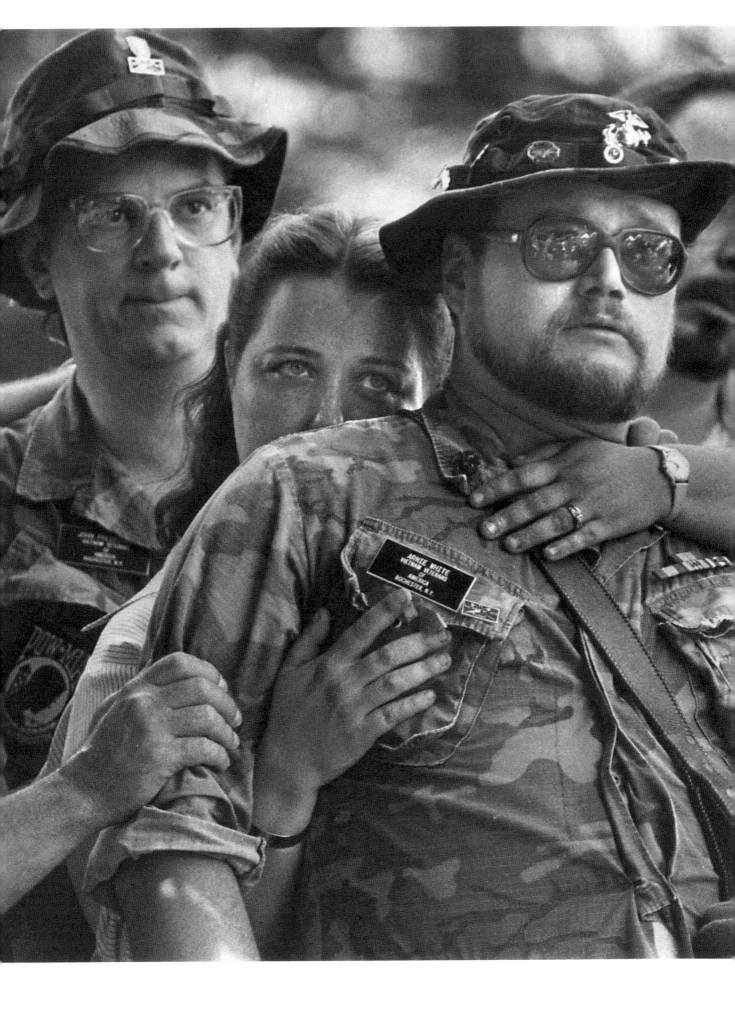

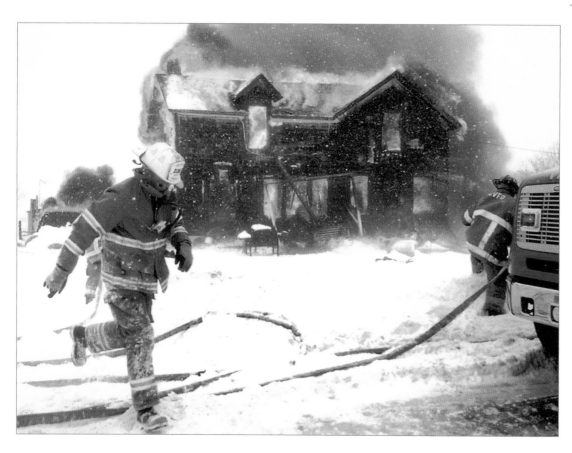

House Fire
March 2, 2005

Virgil Fire Chief Mike McCrory runs to a fire truck as firemen rush to extinguish a burning house on Route 215 in Virgil on a cold March morning.

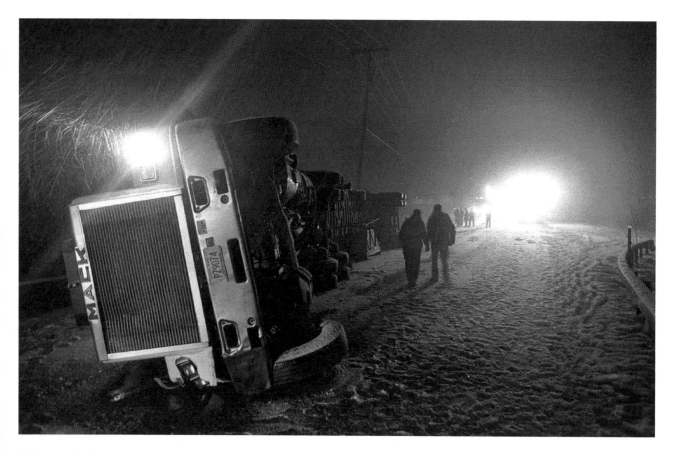

Winter Rollover
2001

A tractor trailer lies on its side after rolling over during a snowstorm on Route 13 near Forbes Road, north of Cortland.

BOB ELLIS, Staff Photographer

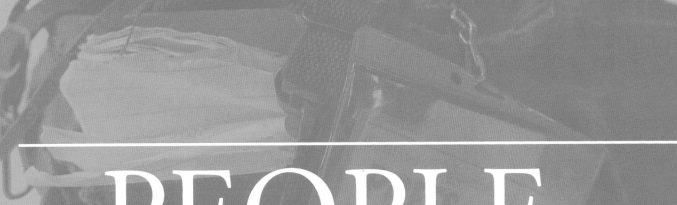

PEOPLE

The faces, the emotions, some well-known to the world,
some only known on the street on which they reside.

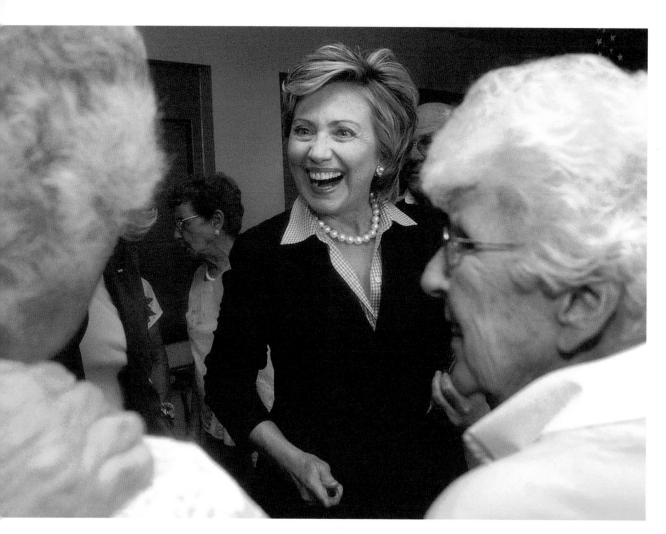

Clinton Visits Seniors
July 16, 2005

New York State Senator Hillary Clinton shares a laugh with senior citizens in
Cortland. Clinton spoke to concerned seniors about social security reform.

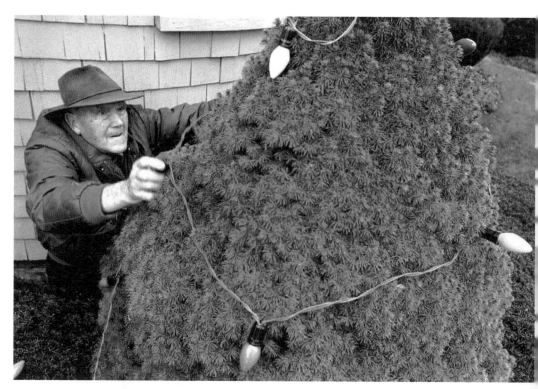

Bentley Decorates
December 13, 2001

George Bentley strings
Christmas lights in his bushes
along the front of his Monroe
Heights home. Bentley joked
that after he is done, his wife
Grace will give final approval
of the work.

BOB ELLIS, Staff Photographer

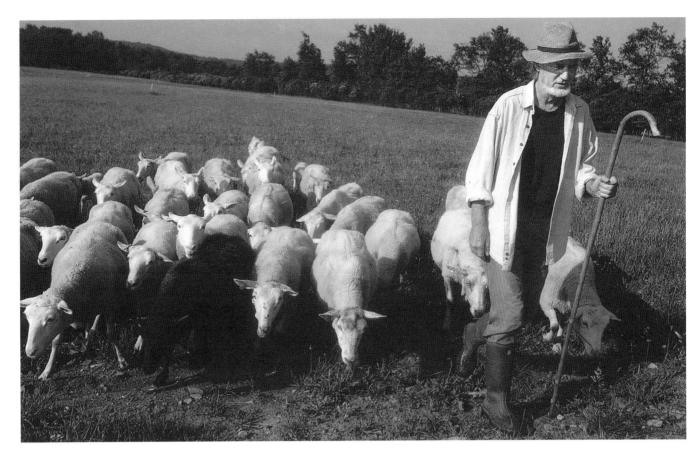

Leading the Flock
June 15, 2005

Freetown farmer Karl North leads his flock of sheep to their morning milking. The sheep's milk will be made into cheese.

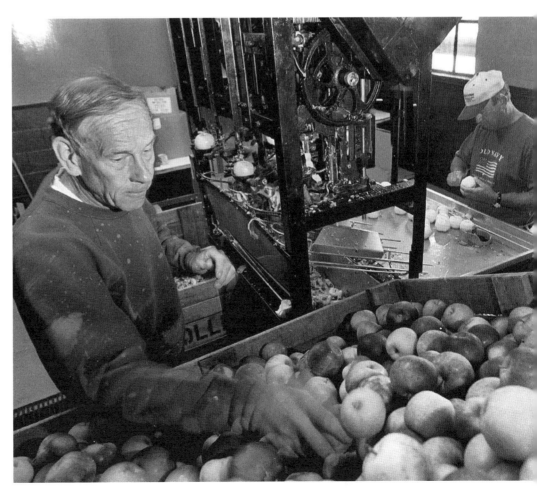

Making Cider
September 18, 2001

Bruce Hollenbeck, left, owner of Hollenbeck's Cider Mill in Virgil, and Louie Digiacomo, peel and cut apples for pies in preparation for their season opener.

Cortaca Legends

November 15, 2008

Tom Decker, left, and Dick Carmean share a laugh at midfield before the start of the Cortaca Jug game between Ithaca College and SUNY Cortland. The two started the jug game in 1958.

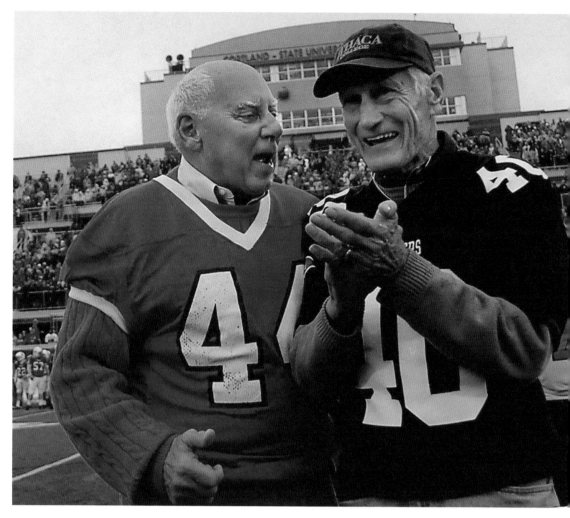

Truxton Depot
July 20, 2005

Former Cortland County legislator from Truxton, George Poole, is framed in the ticket booth window as he walks through the old railroad depot the town is hoping to renovate into town offices.

BOB ELLIS, Staff Photographer

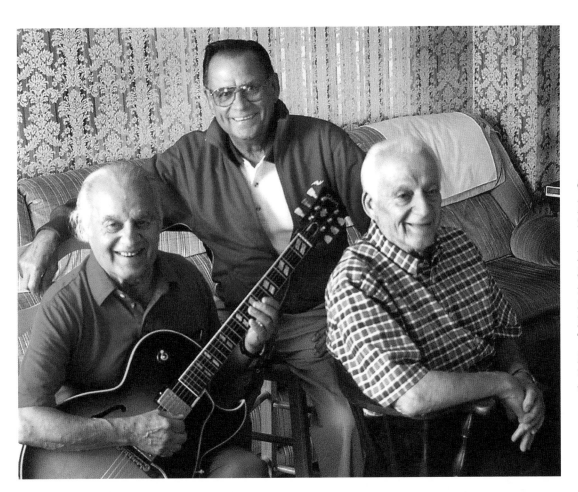

Cosimo Brothers
September 21, 2004

Left to right: Pat, Sam, and Phil, get together in their South Main Street home in Cortland. The brothers have played music together since they were children.

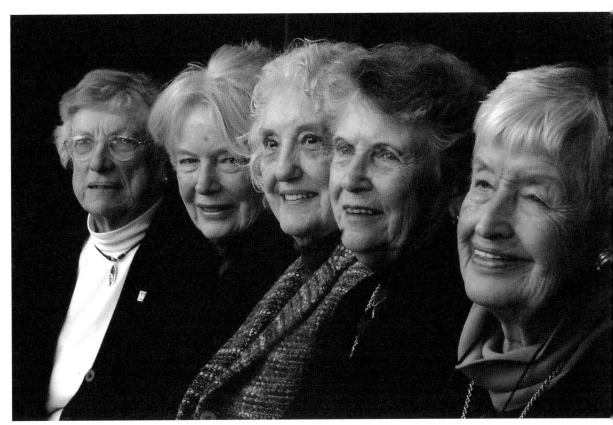

Cortland Divas
March 17, 2007

Left to right: Pat Clark, Mary Alice Bellardini, Elsie Gutchess, Holly Greer, and Betty Brevett. The women were honored for their achievments and contributions.

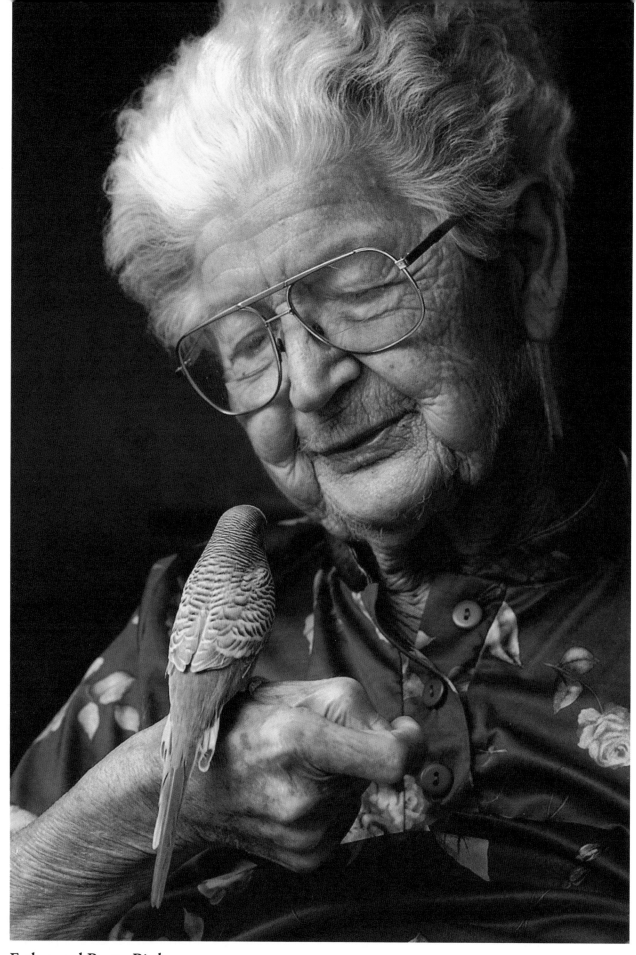

Esther and Pretty Bird
August 29, 2005

Esther Maybury plays with "Pretty Bird", the staff parakeet at Cortland Memorial Nursing Facility.

BOB ELLIS, Staff Photographer

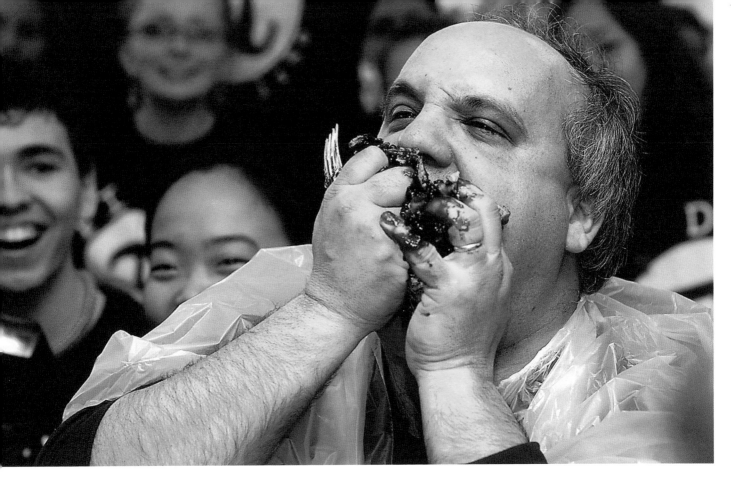

I'll Have a Bite
March 14, 2005

Homer High School math teacher Craig Allen crams blueberry pie into his mouth during a pie eating competition at Homer's First Annual Pi-Day, celebrated internationally March 14th because the digits correspond to the approximate value of pi, which is 3.14. Allen won the teachers competition.

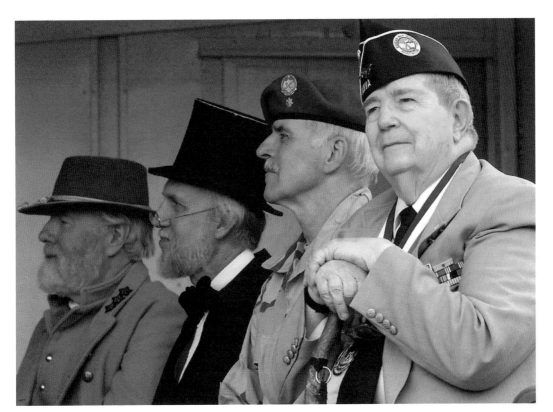

History Day Soldiers
May 18, 2007

An unusual mix of men sit side by side during speeches at the Living History Day program at Homer High School. Left to right are, Dick Crozier portraying General Robert E. Lee, Homer teacher Martin Sweeney as William Stoddard, who was born in Homer and was the assistant personal secretary to Abraham Lincoln and John Reidy, of Syracuse who served in WWII with the Army and in the Korean War with the Navy.

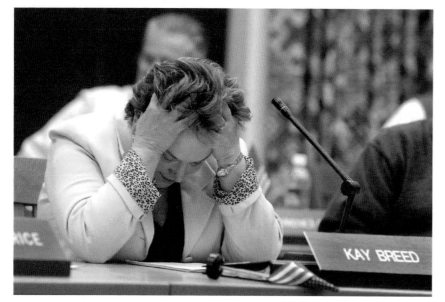

Frustration
January 25, 2007

Very frustrated county legislator Kay Breed tries to clarify the wording of a resolution during a legislature meeting concerning the proposed mental health center.

Willis Streeter
August 30, 2001

Willis Streeter, Sr. weighs tomatoes at his vegetable stand on Elm Street in McGraw as his wife Lucille looks on. Streeter has been selling his homegrown veggies in the area for 40 years.

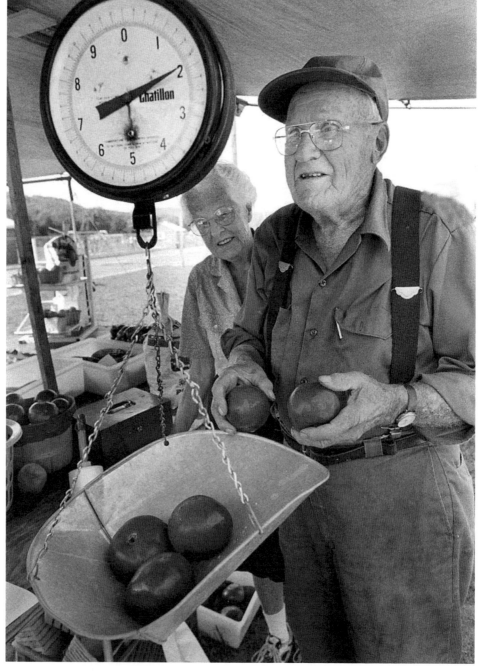

BOB ELLIS, Staff Photographer

Safe!
July 18, 2007

Longtime Cortland umpire Jim Partigianoni calls Art D'Addario safe at first from his easy chair along the first base line. The action took place during the annual Old Timers Fastpitch game at Meldrim Field. Partigianoni, who is also a City Councilman, has been umpiring for over 50 years.

Oath of Allegiance
November 16, 2004

Mariya Filipovna Rud, 83, of Ithaca, takes her oath of allegiance during a Naturalization Ceremony at Groton High School. Rud is originally from the Ukraine.

BOB ELLIS, Staff Photographer

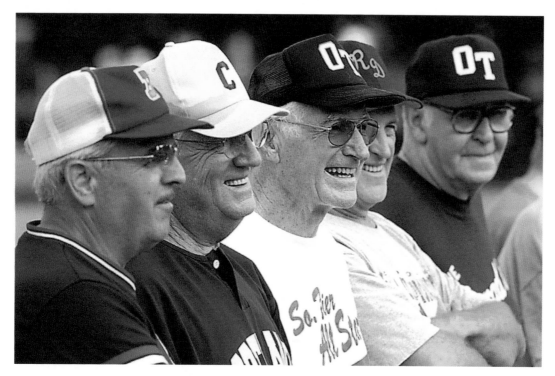

Old Timers
July 21, 2004

A group of Old Timers stand on the first base line during player introductions at the Old Timers Fast Pitch Game. Left to right are: Harold Foster, Harley Bieber, Bill Griffen, Denny Zach, and Gurdon Bush.

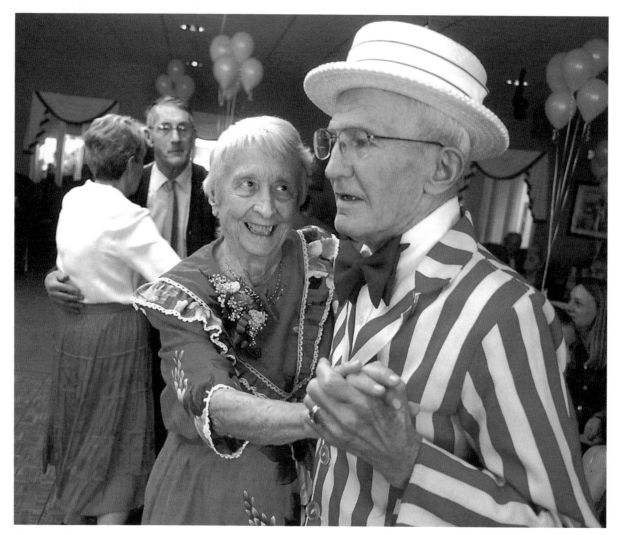

Senior Prom
April 8, 2006

Betty Washburn has her eyes on her dance partner Don Cady during a dance at the Senior Prom held for residents and guests at Walden Place in Cortland. In the background, Ed O'Donnell dances with his wife Eileen.

BOB ELLIS, Staff Photographer

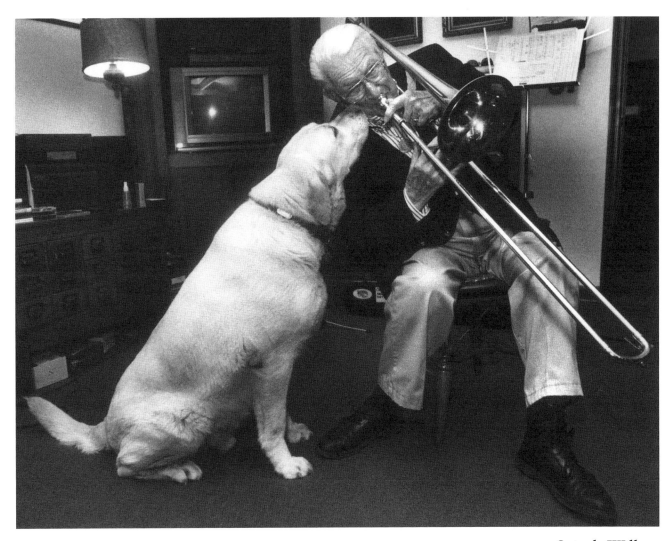

Spiegle Willcox
April 1993

Spiegle Willcox's dog Lynn Dee, gives him a kiss as he plays his trombone at his home near Cincinnatus.

Photo won 1st place in "People and Personalities" category in 1993 Associated Press Photo Contest

Ice Cream Face
November 24, 2008

Dryden Central School District superintendent Sandy Sherwood makes a face after being made into an ice cream sundae by the elementary school students. The event was put on by the Dryden PTA to reward students for a fundraising event. Staff members had to slide through pudding and eat chocolate covered crickets.

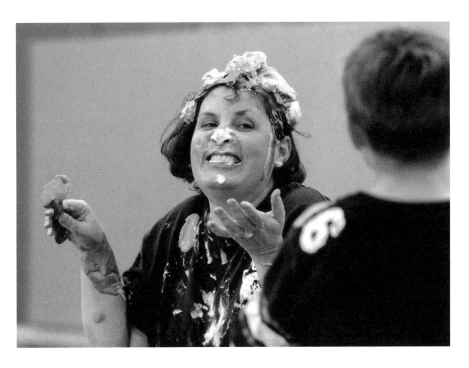

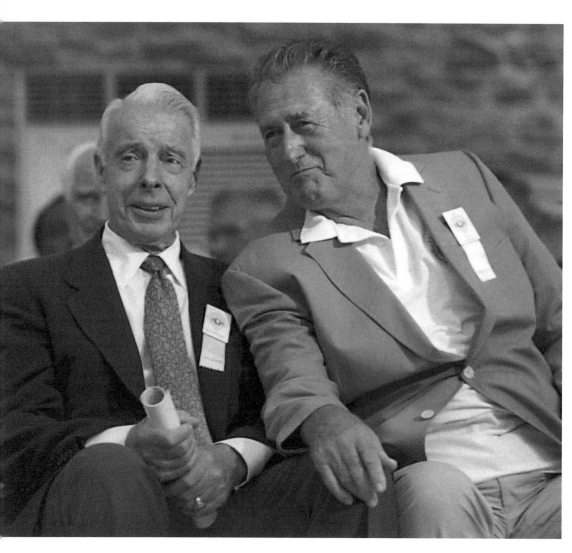

Williams and DiMaggio
July 22, 1991

Baseball greats Joe DiMaggio, left, and Ted Williams chat during Baseball Hall of Fame inductions in Cooperstown.

Jo Zaharis
March 10, 2008

On her 95th birthday, Jo Zaharis, of Cortland, reads to children at the Child Development Center on Pomeroy Street. The former school teacher, who began her teaching career in the early 1930's, received birthday cards from the children and enjoyed cupcakes.

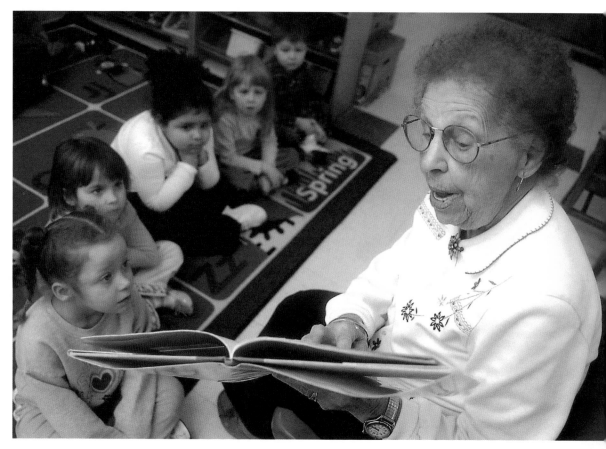

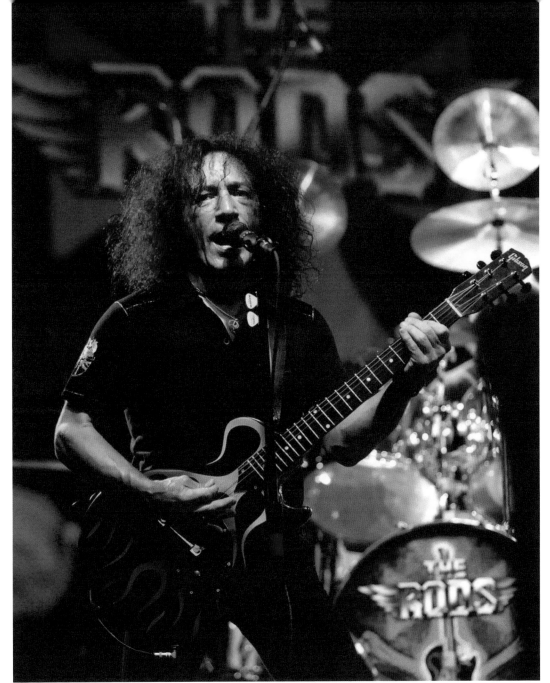

Rock Feinstein
August 1, 2008

David Feinstein belts out a vocal during a performance by The Rods at the Main Street Music Series in Cortland.

Life is Good
April 19, 2005

Life appears good for Duane Bonawitz, of Cortland, as he lounges beneath his umbrella while watching a Cortland High School varsity softball game at Meldrim Field.

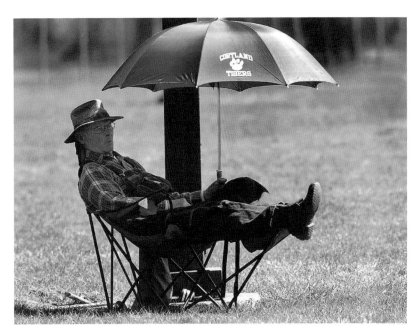

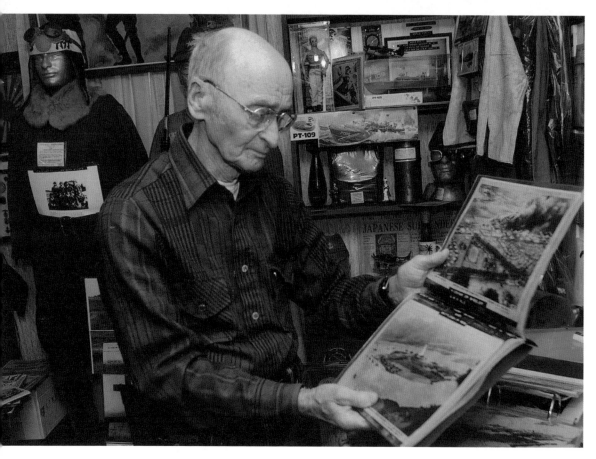

Eaton's Homeville
May 28, 2003

Homeville Museum owner Ken Eaton looks over actual photos of Pearl Harbor taken by Japanese pilots during the attack on December 7, 1941. Eaton owns one of the most extensive collections of WWII memorabilia in the area.

Sweet Adelines
November 2, 2004

Paulette Young, center, leads The Sweet Adelines through a dress rehearsal for an upcoming show.

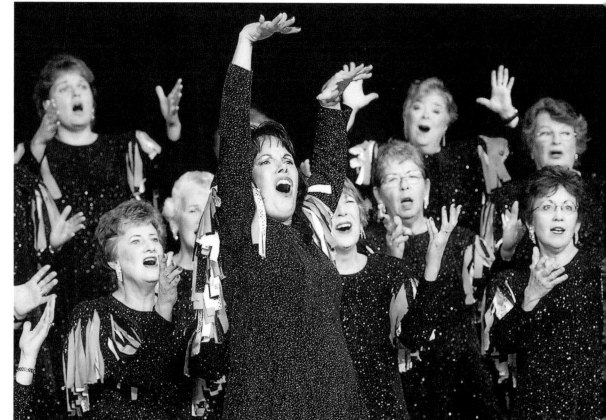

BOB ELLIS, Staff Photographer

PLACES

Cortland County and the surrounding area are among the most beautiful areas in New York State.

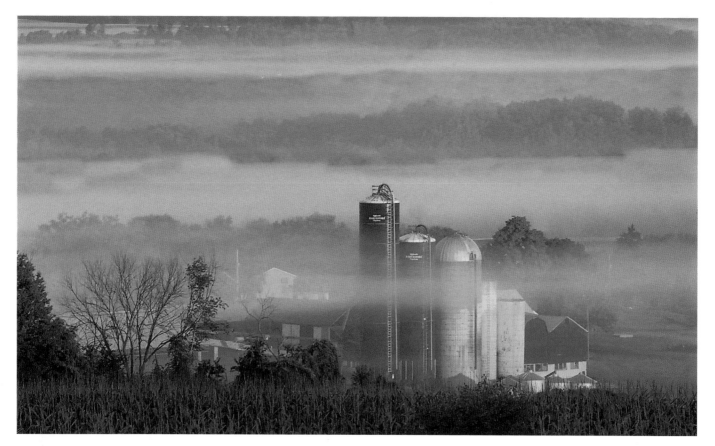

Sunrise Over McLean
August 22, 2006

Valley fog settles in as sunrise reflects off the silos of ChFloKie Farm on Gulf Hill Road, just outside of McLean.

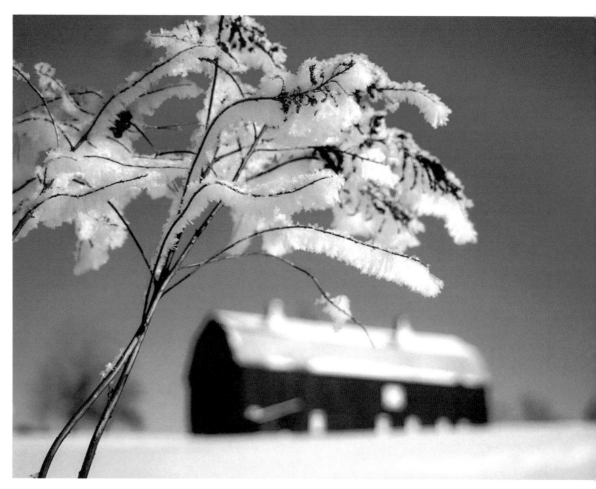

Winter on McDonald Road
December 8, 2005

Early morning snow sticks to a plant on McDonald Road in the Town of Homer.

BOB ELLIS, Staff Photographer

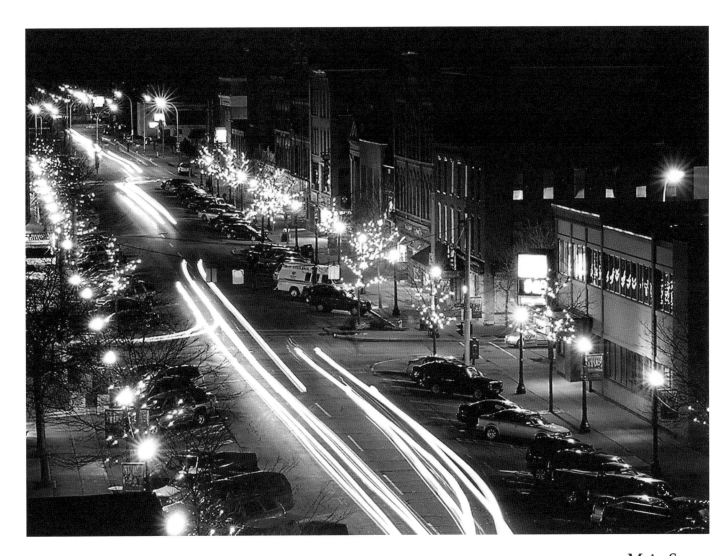

Main Street
December 1, 2005

Shoppers kept Main Street in Cortland busy as cars drive past trees decorated with lights for the holiday season.

Labrador Mountain
January 5, 2005

A downhill skier skis across what looks like a moonscape at Labrador Mountain in Truxton.

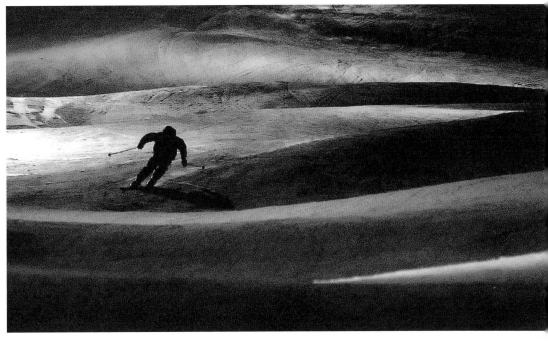

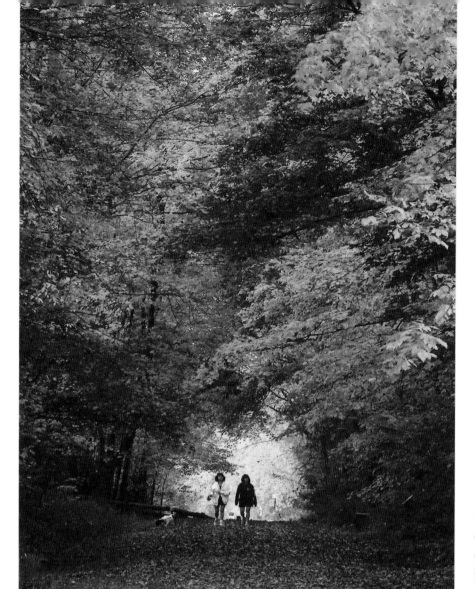

Pond Reflections
November 3, 2010

A barn, tree and foot bridge are reflected in a pond in Cuyler on a chilly fall morning.

Fall Foliage
October 22, 2007
Sue and Nancy Chase, of Dryden, take in the fall colors as they walk on the James Shlug Trail along Dryden Lake.

Homer Antiques
September 18, 2008

Carletta Edwards sets out antique furniture in front of Main Street Antiques and Gifts in Homer.

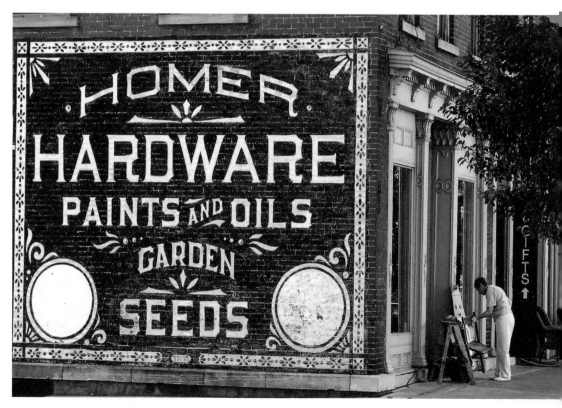

BOB ELLIS, Staff Photographer

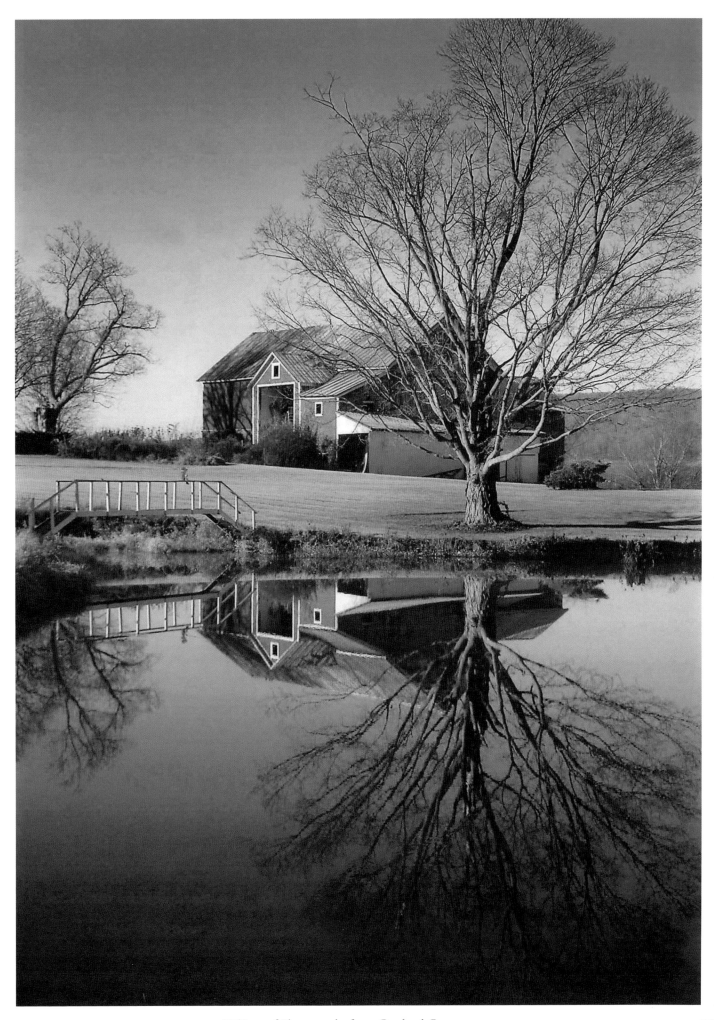

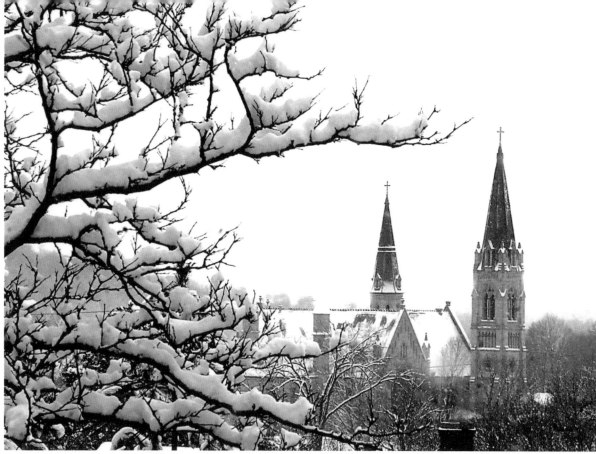

Morning
February 27, 2008

The steeples of the snow covered Saint Mary's Church on a cold winter morning, seen from the SUNY Cortland campus.

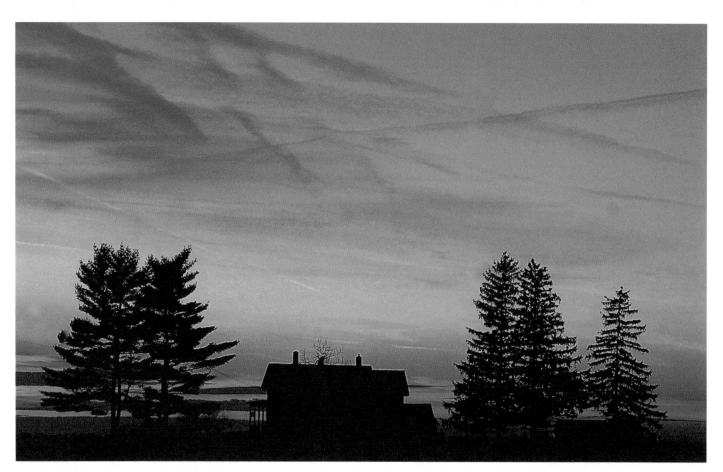

Sunset
November 17, 2004

A fall sunset silhouettes a farmhouse along the McLean-Peruville Road.

BOB ELLIS, Staff Photographer

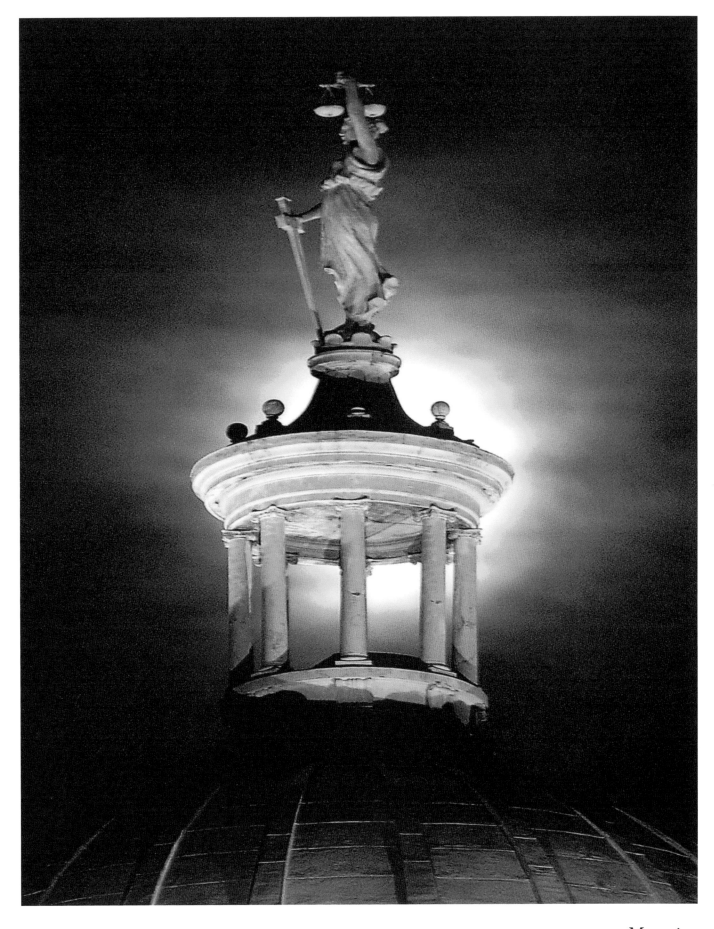

Moonrise
October 26, 2004

A nearly full moon rises over the Cortland County Courthouse.

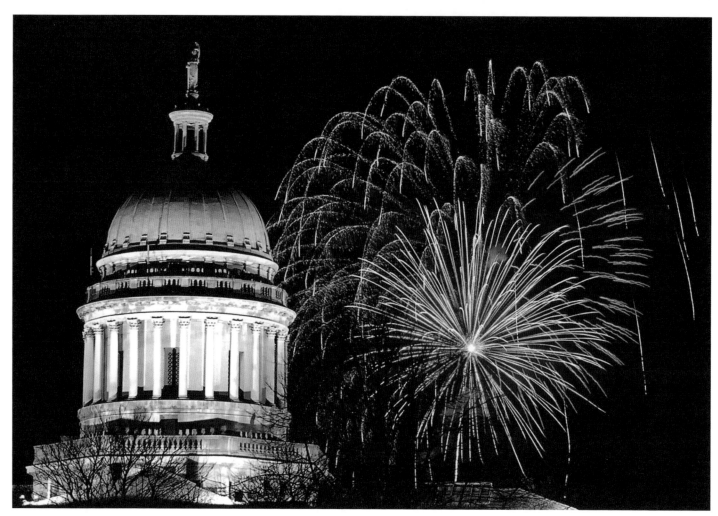

Fireworks
April 8, 2008

The Cortland County Courthouse provides the backdrop for Cortland County's bicentennial fireworks display.

Winter In Homer
January 15, 2005

This winter scene from McDonald Road, above the Village of Homer, shows the Center For The Arts, left, the First United Methodist Church, and the Homer Congregational Church.

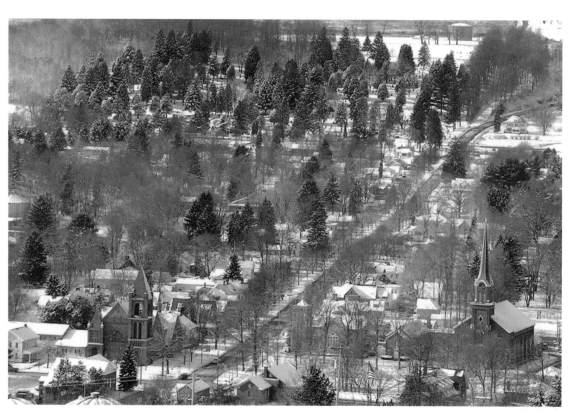

BOB ELLIS, Staff Photographer

SPORTS

Sports is for the young and old alike. You can feel the highest of highs and the lowest of lows, the entire spectrum of emotions.

DeRuyter Basketball
March 1995

DeRuyter High defenders leap as they triple team Owen D. Young High School player Reggie Burks in the Section III Class D-2 title game. DeRuyter players are, left to right, Jim Pforter (54), Warren Hakes (12) ,and Marc Warlock. DeRuyter won the championship game, 71-52.

Photo won 2nd place in the March 1995 NPPA monthly clip contest

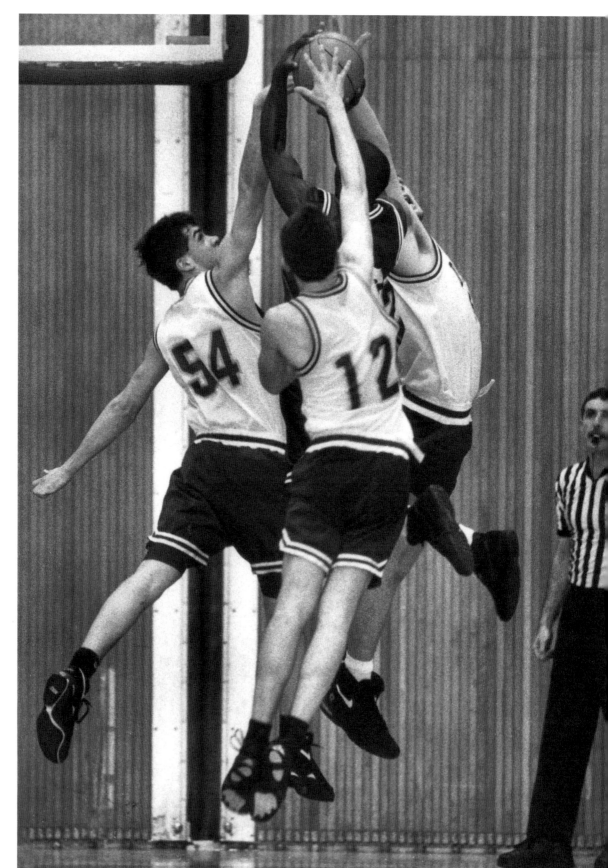

BOB ELLIS, Staff Photographer

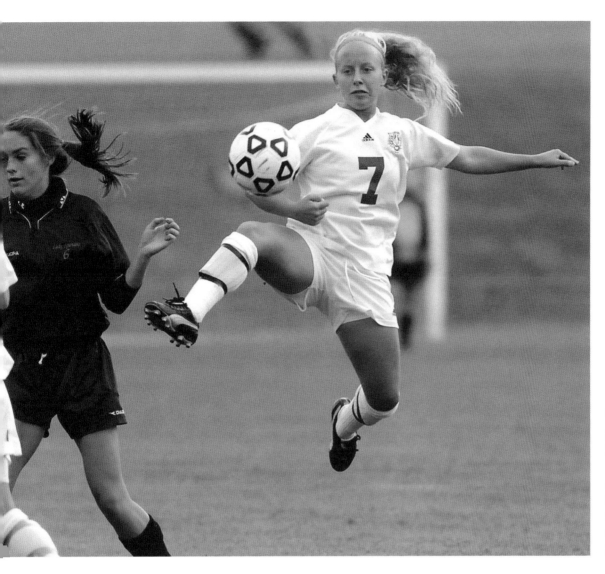

Cortland Soccer
September 11, 2008

Alexis Keeney of Cortland leaps to push the ball upfield against East Syracuse-Minoa.

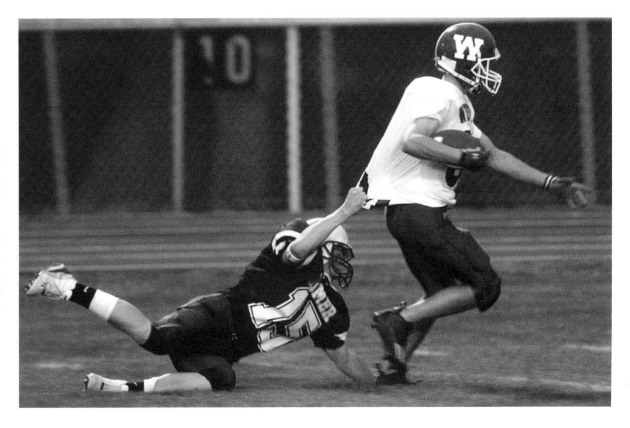

Homer Football
September 13, 2003

Ryan DuBois (15) of Homer, grabs the shirt of Westhill receiever Brian DeCarr to save a touchdown.

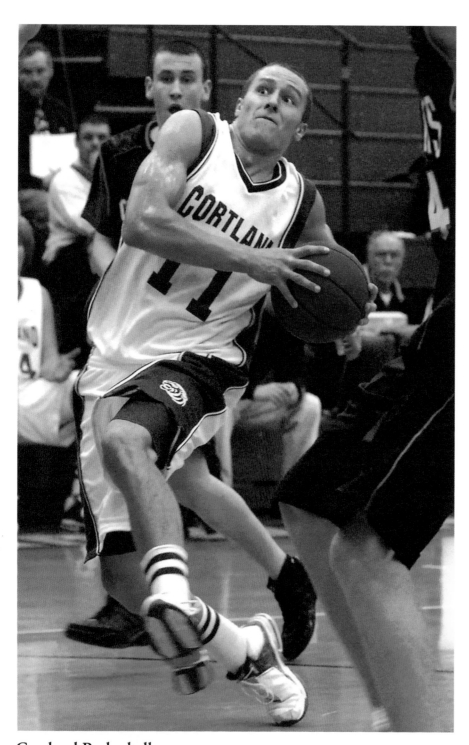

Cortland Basketball
December 5, 2006

Joel White, of CHS, drives the lane against East Syracuse-Minoa.

BOB ELLIS, Staff Photographer

Marathon Girls' Basketball
March 6, 1993

Mickey Solowiej (23), of Marathon High School, leaps to attempt to block a pass by Sara Gage (21) of Stamford High School in the Section IV Class D championship game at the Broome County Arena. Marathon lost the game 54-36.

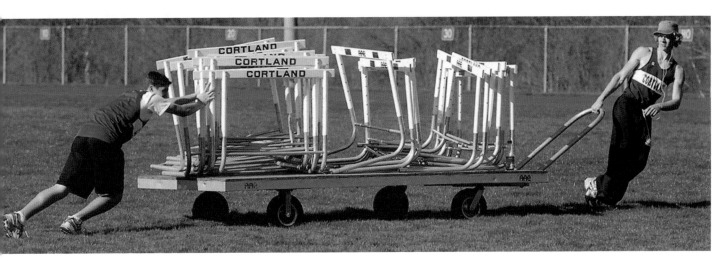

Pushin' and Pullin'
May 2, 2007

Cortland High School track team members Matt Edwards pulls as Seth Nelson pushes a cart load of hurdles across a very soft and soggy football field. The boys were in the process of setting up the hurdles for the next race.

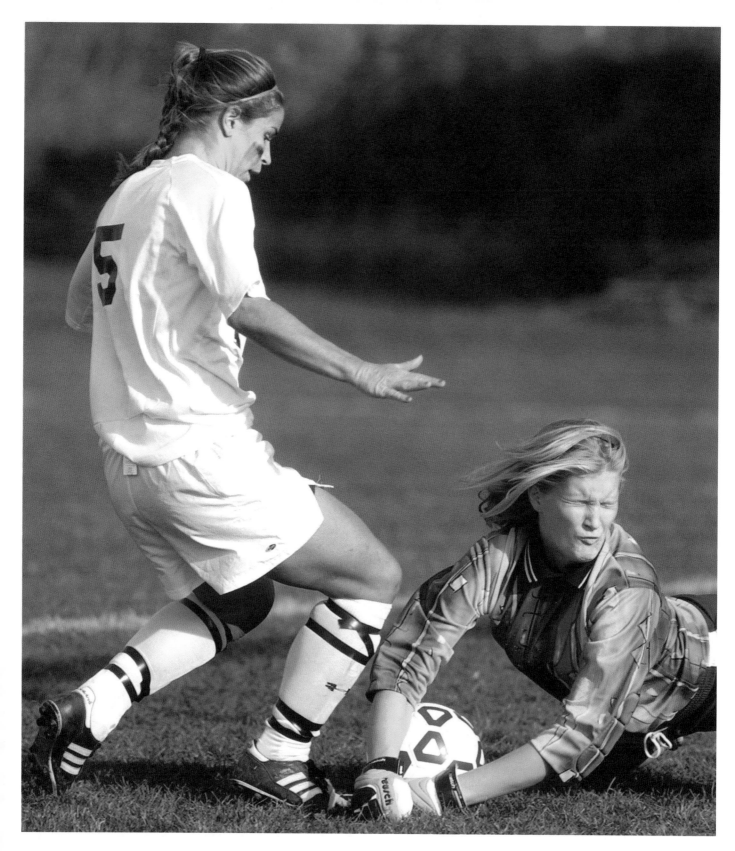

Homer Soccer
October 28, 2004

The Indian River goalie makes a first half
save on a shot by Kelly Finn, of Homer.

BOB ELLIS, Staff Photographer

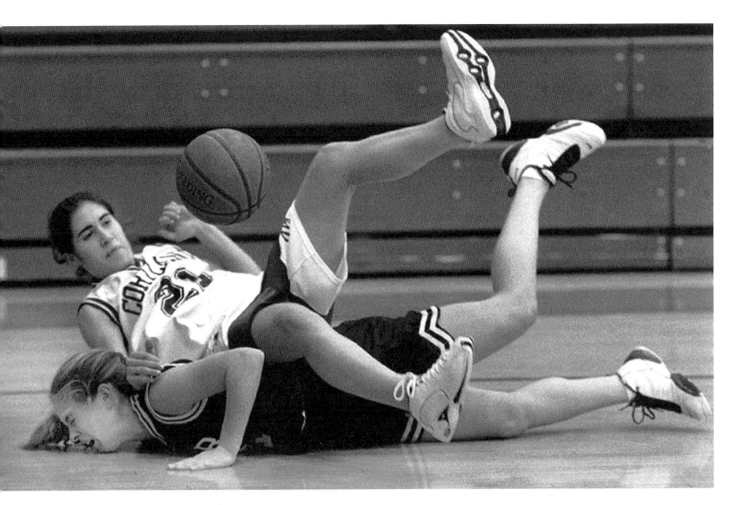

Ouch!
February 5, 2002

Andrea Piedigrossi, of Cortland High School, tumbles
over Kristen Reakes, of Homer, while chasing down a loose ball.

Shadow Game
October 5, 2006

Homer High School
varsity tennis player
Kelly Noble, casts
a shadow during a
match at Homer
High.

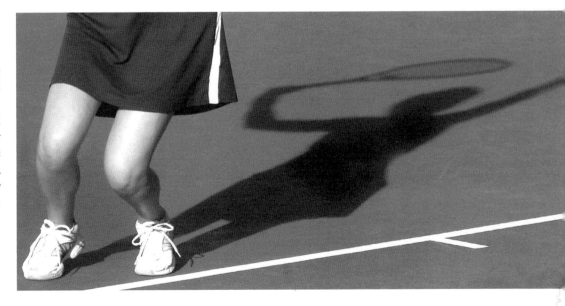

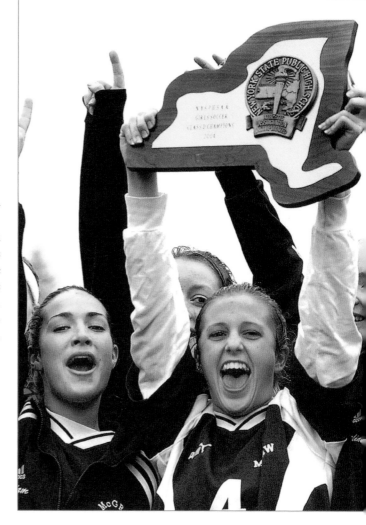

McGraw's #1
November 20, 2004

Ashley McAdam, left, and Taryn Bilodeau scream as they hold the team's championship plaque aloft while celebrating their New York State Class D soccer championship in Binghamton. Bilodeau scored the games only goal to beat Chateaugay Central School, 1-0.

Cheerleader with Many Arms
November 6, 1996

Cortland High School cheerleader Staci Fisher appears to have grown many arms as she performs a halftime routine with teammates at a football game at the Carrier Dome in Syracuse.

BOB ELLIS, Staff Photographer

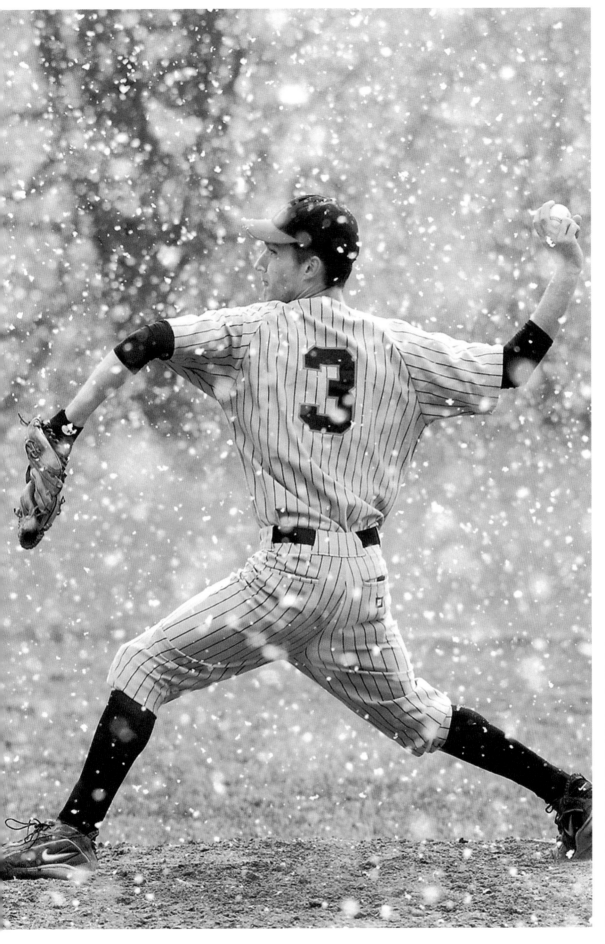

Marathon Snowball
April 5, 2006

Marathon pitcher Dan Bleck throws a pitch through a heavy snowfall in Marathon in a game against Groton. Although the snowfall let up, the teams played two innings before umpires and coaches agreed to call the game off.

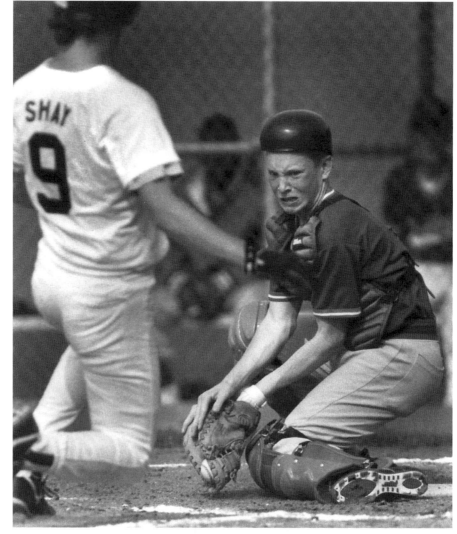

Cortland High Baseball
May 16, 1990

Nottingham High School catcher John Duncan grimaces as he prepares to slap the tag on Bob Shay, of Cortland High, on a play at homeplate at Beaudry Park.

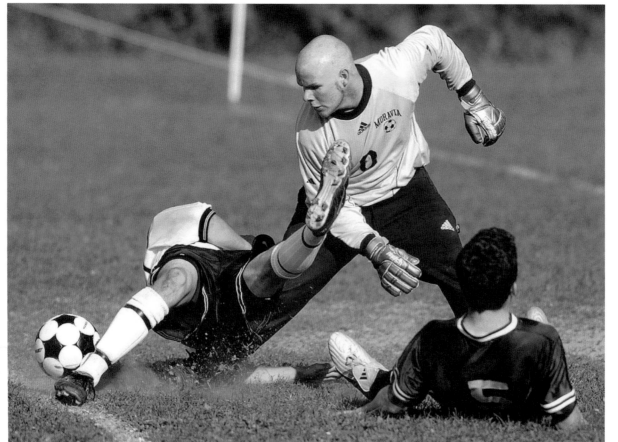

Moravia Soccer
September 14, 200.

Moravia goalie AJ Rouse looks to grab the ball as Maratho player Matt Bramen left, and Moravia player John Guido, right, hit the turf.

BOB ELLIS, Staff Photographer

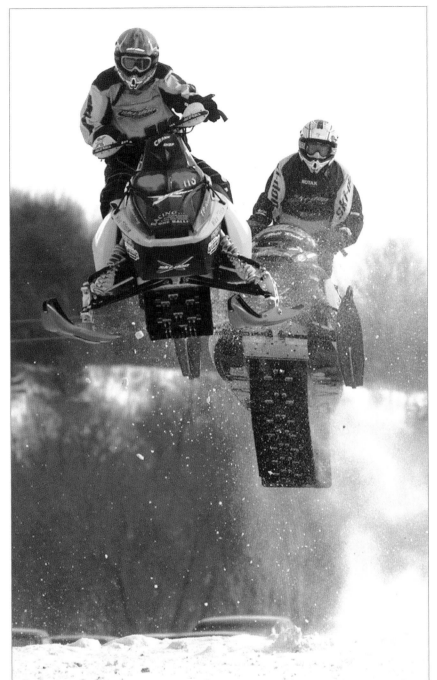

Flying Snowmobiles
January 24, 2004

Racers take to the air during a qualifying race at the Big East Snocross Tour in Polkville.

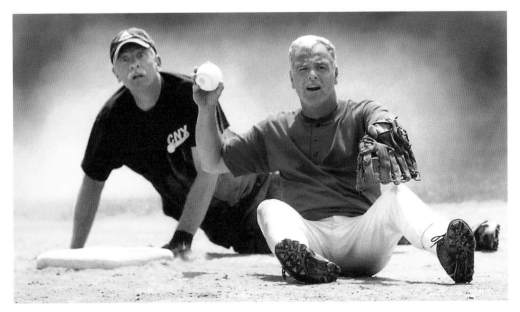

I'm Out!
June 11, 2004

Bob Rood, left, of the CNY's-50's, can't believe he was called out on this close play at second base. Joe Bregg, of Gandy's Dancer's in Potsdam, made the tag. The two teams were competing at the Empire State Senior Games.

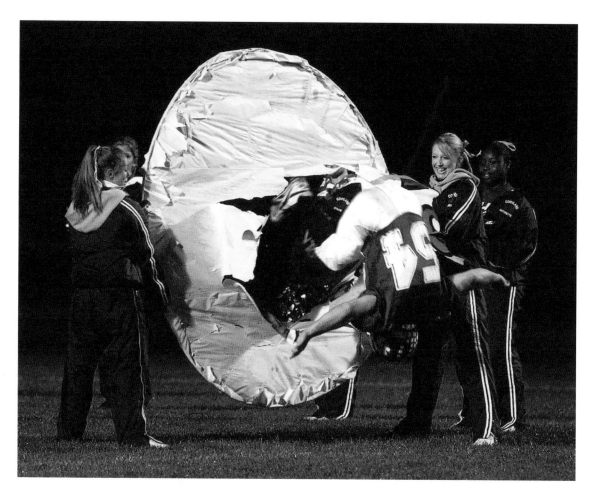

What An Entrance
October 14, 2005

Cortland High varsity football player Mike DeGouff does a flip through a paper covered hoop held by cheerleaders as the team takes the field in a game against Fulton.

Out at Second
May 3, 1996

Chrissy Corless, of Fowler High School, lies in disbelief after being called out by umpire Jim Van Wagenen, left, while Cortland High School shortstop Laura Dillenback, and second baseman Ang Tutino celebrate the out by slapping a high-five. Cortland went on to win, 19-0.

Photo won 2nd place in sports category in the NPPA Montly Clip Contest

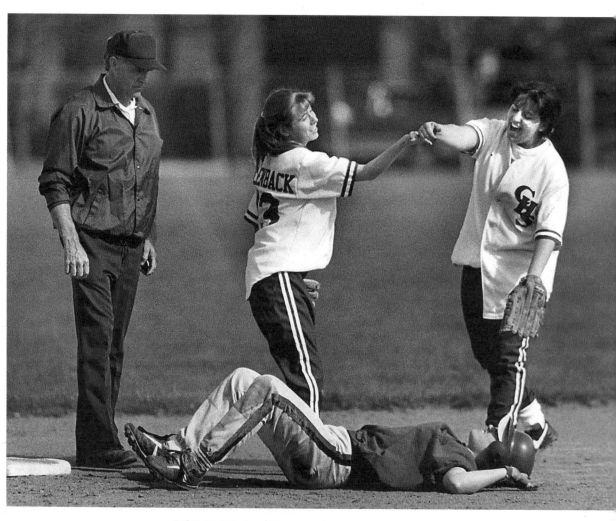

BOB ELLIS, Staff Photographer

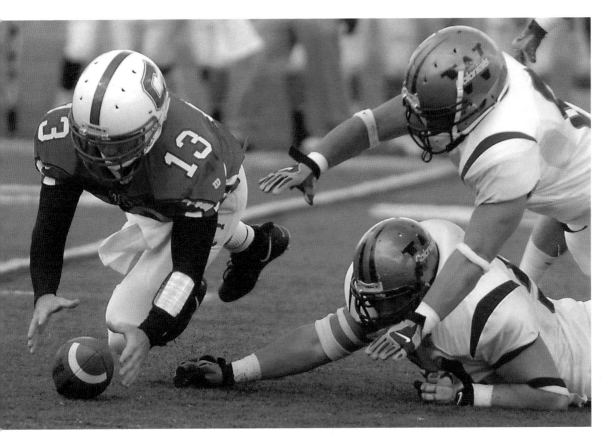

SUNY Cortland Football
October 13, 2007

SUNY Cortland QB Ray Miles (13) beats Western Connecticut defenders to recover a fumble.

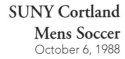

SUNY Cortland Mens Soccer
October 6, 1988

Greg Novitsky, right, of Cortland State, collides with a Gettysburg State player during a soccer game.

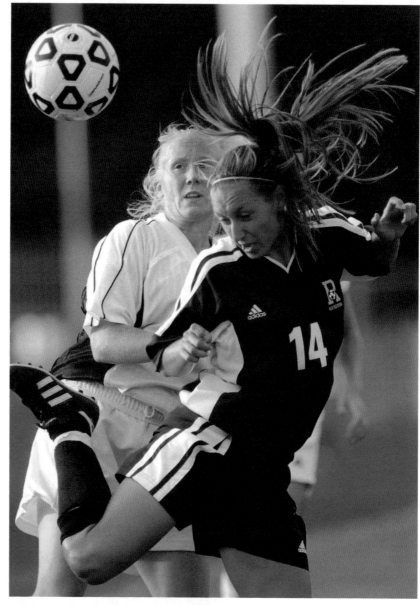

SUNY Womens Soccer
September 10, 2002

Brinn Spencer, left, of SUNY Cortland closes in as Liz Morrison (14), of the University of Rochester, kicks the ball into the air.

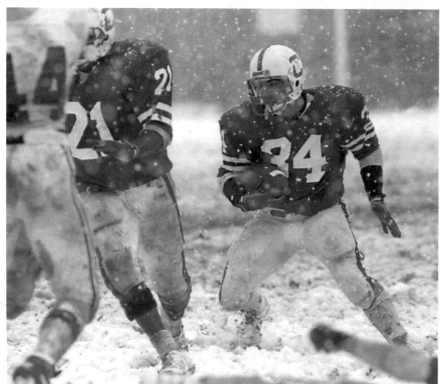

Snow Bowl
October 24, 1988

Nick Amodio (34), of SUNY Cortland, dodges snowflakes and Springfield University defenders as he follows the block of Gareth Grayson (21) during a game played in a fluke October snowstorm. SUNY Cortland won 7-3.

BOB ELLIS, Staff Photographer

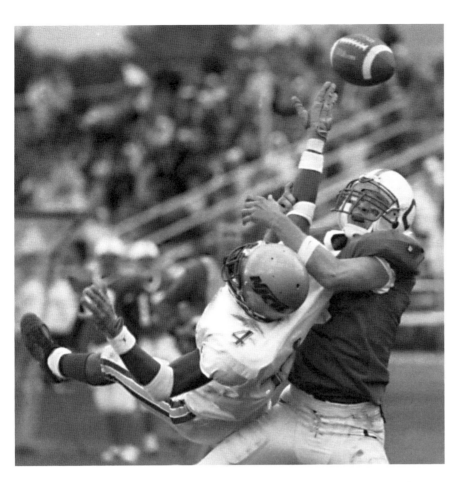

SUNY Football
October 8, 2001

New Jersey City College defensive back Shariff Battle (4) breaks up an end zone pass intended for Brian Babst, of SUNY Cortland.

Photo won 3rd place in sports category in NPPA Region 2 monthly photo contest

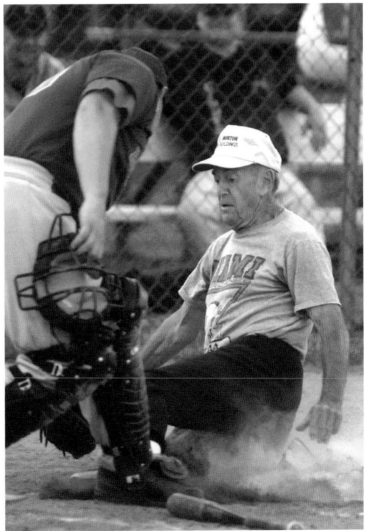

Old Timers
July 19, 2006

75 year old Dick Finn slides safely into home, beating the tag of catcher Jared Wood during the annual Old Timers game at Meldrim Field.

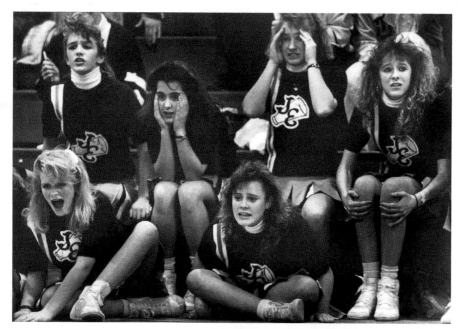

Worried Cheerleaders
1990s

Cheerleaders from Jordan-Elbridge High School, show varying degrees of concern as they cheer at a wrestling match at Homer High School.

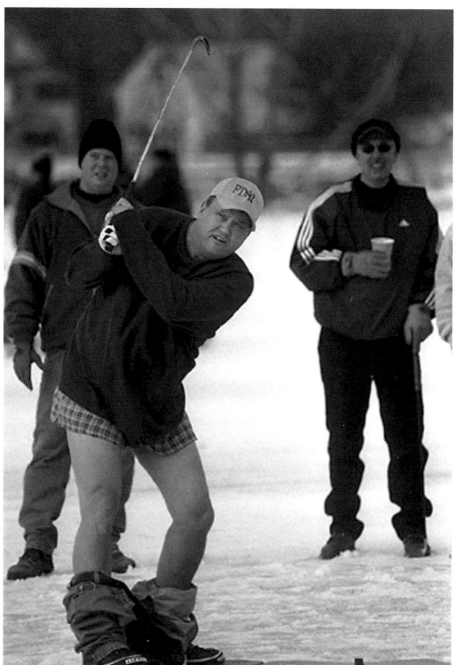

No Pants
February 16, 2002

Tom Powers, of Moravia, loses his pants as he golfs in Debbie's Lake Como Yacht and Country Clubs 8th Annual Golf Tournament on Lake Como. The course was layed out on the frozen lake.

BOB ELLIS, Staff Photographer

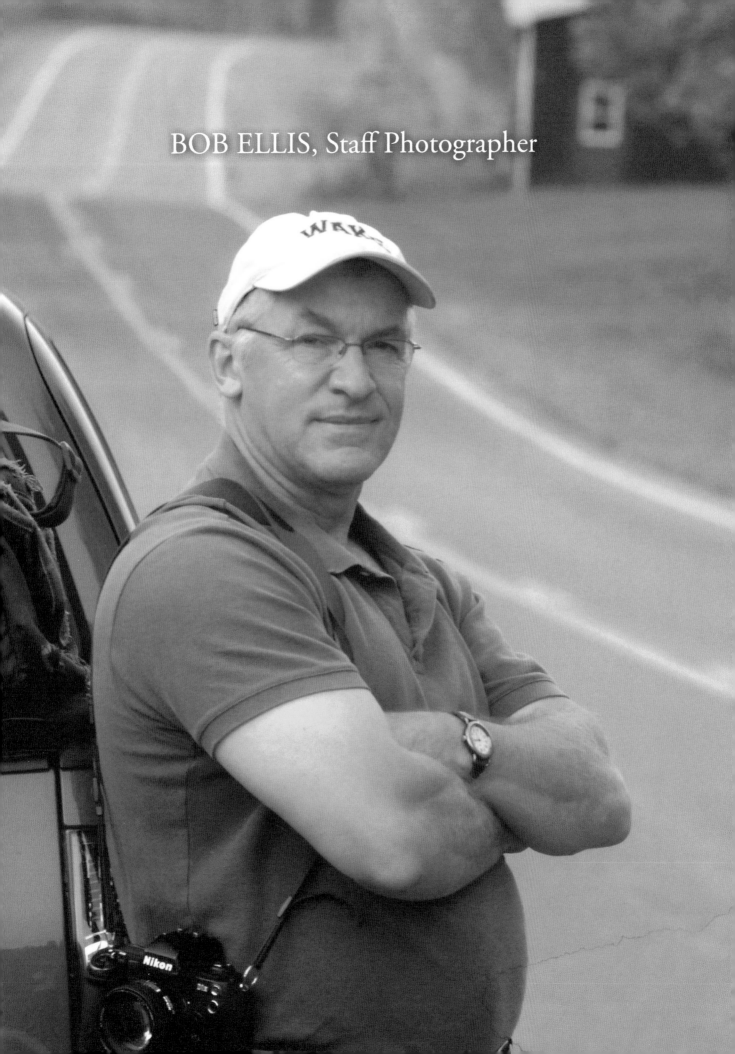

BOB ELLIS, Staff Photographer

Made in the USA
Charleston, SC
20 June 2012